IMAGES
of America

ROCHELLE

CONTENTS

ACKNOWLEDGMENTS

I recognize and say thank you to the following persons for their help—be it much or minimal—in supplying information, photographs, or encouragement for the making of this book: Flagg Township Historical Museum (FTHM) and its board members, Mayor Chet Olson, Becky Leifheit, Betty Barnes, Franklin Kruger, Leonard Carmichael, John Guio, Margaret Knight, Arlyn and Debby Van Dyke, Peri Query, Ted Tilton, Vicki Snyder-Chura, Marguerite Thomas, Rob Whipple, Don Horner, Dr. and Mrs. Tom Koritz, Diane Charnock Fischer, the clerks at Flagg Township Library, Jayna Albert, Naomi Baldwin, Janet Rigg, Bobbie Colbert, Jim Hovis, Ray Swartz, Robert and Grace Gott, John Bienfang, Richard Ohlinger, Sue and Denny Golden, Todd Prusator, Mary Jo Moreland, Kelly Kersten, Amber Goluszka, Kelly Messer, Shawn Higgs, Dot Allen, Harry Connor, Barry Schrader, Leah Anderson, David Hegberg, Joel Hegberg, Colleen Hegberg, Marie O'Connor, and Jeff Ruetsche, my editor.

A huge thank you to the late Art Nelson, for his vintage Rochelle photograph collection. Most images come from his collection, which I found unfiled in the FTHM. Art was detailed about captions; however, his spelling often contradicted itself. I double-checked spellings with other sources when possible. If I misspelled a friend's or relative's name, please forgive the error.

MAYOR'S WELCOME

On behalf of the city council and as mayor of Rochelle, I welcome you to our community.

Established in 1853, the city of Rochelle has grown to a population of over 9,500. With a small-town look and feel, Rochelle offers large-town services and an outstanding quality of life.

Rochelle has long been known as the "Hub City." Major transportation arteries crisscross here: the north-south distribution corridor of I-39 and the east-west research corridor of I-88 with two state routes—Illinois 38 and 251. The Lincoln Highway 38 stretches from California to New York State. The junction of the Burling Northern Santa Fe with the Union Pacific Railroad provides an excellent opportunity to access two western transcontinental railroads. The City Industrial Rail provides dual access to both mainlines. The Union Pacific Global III Intermodal Transportation Facility provides fast, efficient, and low-cost shipping. The Rochelle transportation system can serve over 80 million people in 15 different states, including Canada, in less than 24 hours. Looking to the future with the Northern Illinois Technology Triangle (NITT) Project, Rochelle is becoming a transportation hub for high-speed broadband fiber.

You will find that Rochelle is a caring and progressive community that works together to meet challenges and solve problems. The new city seal and high-tech logo reflect the cutting-edge nature of our services. Our parks, schools, industries, city-owned utilities, and retail businesses contribute to the modern spirit of the community and have much to offer both long-time residents and future citizens.

Tourist attractions include the Lincoln Highway and Rail Fan Park. The viewing platform at the "diamond" intersection of the mainline railroads attracts thousands of visitors from around the world. Annual celebrations like Memorial Day, Fourth of July, Heritage Festival, Railroad Days, Farmers' Market, and the Hispanic Festival are opportunities for community involvement, fellowship, entertainment, and fun.

I welcome you to visit our community and enjoy the hospitality found only in the progressive city of Rochelle, Illinois.

Very truly yours,
Chet Olson
Mayor of Rochelle, Illinois

ALONG A

POTAWATOMI TRAIL

In the early 1800s, a Potawatomi brave tied the top of a sapling to the ground to grow into a trail marker for his and other tribes, such as the Ottawa, and the French voyageurs, who still inhabited the area since the War of 1812.

These nomadic people camped along the Kyte River for water and in the thick stands of trees for shelter. The area, known for its plenitude of fowl, was composed of prairie grasses, unbroken sod, and wetlands.

With less than 40,000 people, Illinois became a state in 1818. Kaskaskia was its first capital, and Justice Ninnan Edwards, its first provincial governor.

Chief Shabbona, from the Ottawa tribe, lived with the Potawatomi bands. He was a tall, husky man whose name meant, "built strong like a bear." He took the Potawatomi trail to the white settlement of Hickory Grove, and eventually because of his friendliness and frequent visits, the road became known as Shabbona Trail in honor of the likable chieftain. That was a peaceful time.

According to *The History of Ogle County*, in March 1835 Jeptha Noe was the first permanent white settler of Flagg Township in Jefferson Grove, also known as Wet Grove, northwest of Highway 38. He constructed his one-and-a-half story log cabin for his family with a shakes roof (wood shingle), a puncheon floor (smoothed split-log), and a split-stick chimney.

William Cochrane and his family came along the Potawatomi trail in November and built a large log cabin near the Noes'. His was large enough to hold Sunday worship services. Besides him and his wife, Cochrane's family included son Homer, daughters Julie Ann and Lucy Lake (a widow), her son, Oscar, and perhaps more.

Mills Steward built the third log cabin in the vicinity of today's Spring Lake. John Fulton was the builder of the fourth log cabin.

More people rode in along the Potawatomi trail in oxen-pulled wagon trains and on the stage lines to establish a settlement known as Hickory Grove. By 1880, it had grown to the largest city in Ogle County and remains so today with 9,600 inhabitants.

One

THE LOBLOLLIES

Known originally as Hickory Grove, Rochelle accrued the nickname of Loblolly Grove. A loblolly was a Southern term for someone who lived around wetlands. Loblolly pines grew best in poor surface drainage soil, such as on the terraces of rivers like Kyte Creek. So the Hickory Grove settlers became known as loblollies.

Loblolly pines are sturdy pioneer trees. Their seeds feed animals, birds, and wild turkeys. Woodpeckers live in their cavities. Hickory Grove became world-known for its bird hunting. Prince Albert of the United Kingdom is said to have hunted there. Loblolly pines were a preview of the people who would create the strong, enjoyable town of Lane.

In 1838, Willard Flagg and the Sheldon Bartholomew family purchased the John Randall property for $1,500. Flagg took the land south of the river, married Lucy Lake in July 1839, and built the second home in Hickory Grove. Flagg Township is named after him.

The first permanent bridge—Rathbun Bridge—recorded in Flagg Township was built around 1850 across Kyte Creek, possibly after Benjamin Rathbun. The Methodist Church records mention baptisms near the bridge in 1860.

Robert Lane, Thomas Robertson, and Gilbert Palmer purchased land from Charlotte Bartholomew, Sheldon Bartholomew's widow. Part of the land was laid out for the village of Lane to honor Robert Lane.

Isaac Ross built the first house in Lane in 1853. David B. Stiles put up the first building for general merchandise and was the first postmaster. Miranda Weeks was the first school teacher; John Bird, the first blacksmith. Bruin Walker managed the first grocery and supply store. Thornton Beatty created the first lumber yard, and George Turkington and M. Ellinwood were the hardware men. Delos Baxter pioneered harness making while starting another hotel and being involved in many city projects. Hinckley Whitman established the first bank. The *Lane Leader* went to press for the first time in 1858.

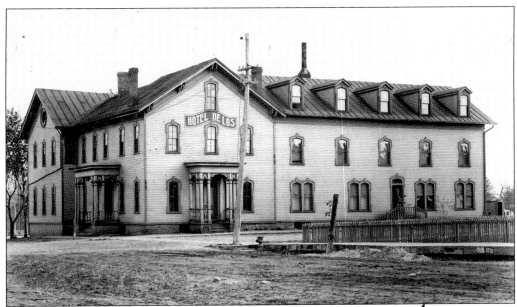

The Lane Hotel was built the summer of 1853 by Horace Coon. The two original sections of the hotel were removed in 1872 and 1893 and moved west on Second Avenue. In 1890, Delos Baxter purchased the Lane Hotel and completely redecorated the interior. Hotel Delos was known as "the traveling man's center" for all the small surrounding towns. J. E. Barber was the manager. (Courtesy of FTHM.)

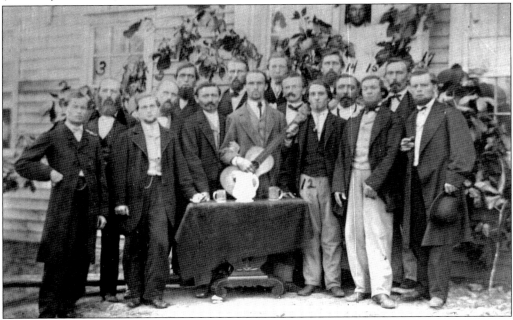

Employees stand in front of the Budlong and Miller Brewery at First Avenue and Seventh Street. During the 1860s and 1870s, a young boy's job was to roll a beer barrel down and back up the long hill near the brewery. During that time and distance, the keg's liquid lining would evenly distribute for no leakages. The job paid a nickel to a dime per day. (Courtesy of FTHM.)

In 1837, the first white settlers in Hickory Grove were John Randall, his wife, their six sons (George, John P., James, William, Ira, and Wesley), and their three daughters (Sarah, Margaret, and Mahala). They built their log cabin on the north side of Kyte Creek, on today's South Main Street. John P. Randall poses among his sons. From left to right are (first row) Osbourne, John P., and Frederick; (second row) Orrin and William. (Courtesy of FTHM.)

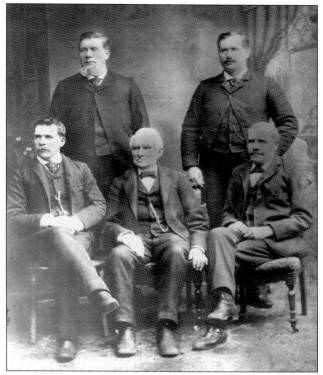

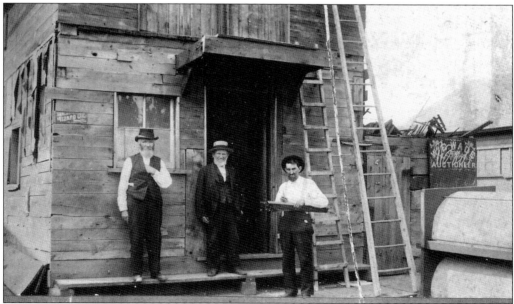

In the late 1870s, Ross Boyle (left), David Navarro Sr. (center), and William Halsey Sr. stand in front of the first factory building. William Edward Wade's woodwork shop was located on Lincoln Avenue's south side and produced wood pumps. Navarro was a 30-year-old bachelor in 1851 when he traveled from New York City to homestead on today's Koritz Field of Rochelle Airport. In his diary, he noted seeing and hearing many wolves. (Courtesy of FTHM.)

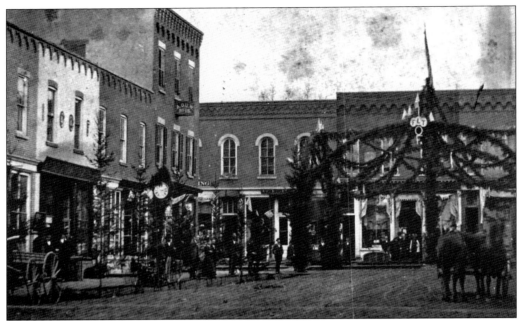

In this image Cherry Street celebrates in 1878. Lane had several fires in 1861. One destroyed the west-side Washington Street buildings—today's 300 block of the Lincoln Highway—and another, a grain elevator. Thomas Burke was arrested. During a trial recess, men seized Burke, tied a rope around his neck, and tossed him out a third-floor window on the corner building seen in the photograph. His body hung in the rain for three hours. (Courtesy of FTHM.)

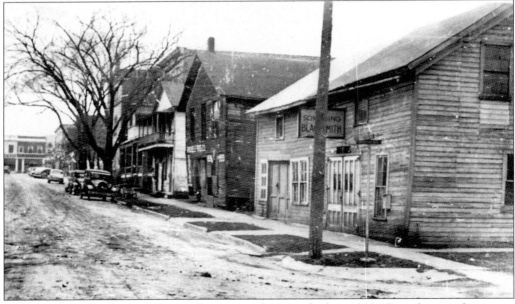

Because of the incident on Cherry Street, seen here in the late 1800s, Lane became known as Hangman's Town. John R. Howlett established the *Lane Leader* in October 1858 and published a special edition on the hanging on June 20, 1861. Prominent citizens went to trial for the murder but were found not guilty. (Courtesy of FTHM.)

After the hanging, Lane's growth stagnated. Someone noticed a Rochelle Salts (laxative) bottle on the shelf and suggested the town needed a "good cleaning out." Joseph Parker's obituary credited him for the name's choice, though an alternative reason was after a Frenchman. In 1866, the Illinois General Assembly changed the name to Rochelle. On April 10, 1872, the citizens elected its village's name to be Rochelle. (Courtesy of FTHM.)

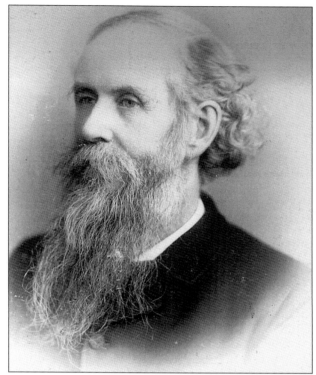

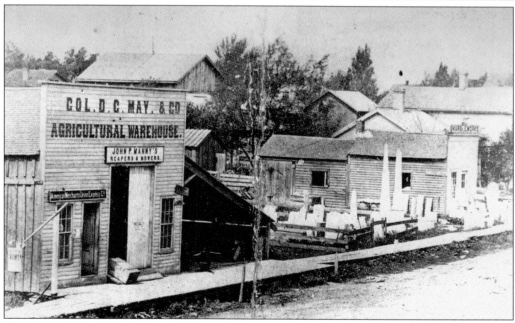

The Colonel May Warehouse in 1872 was located on the west side of Washington Street. Notice the location of the American Merchants Union Express Company. Next door stood the Marble Works, which was operated by Billy Bell. The next house belonged to Si May and was removed for the construction of a theater. (Courtesy of FTHM.)

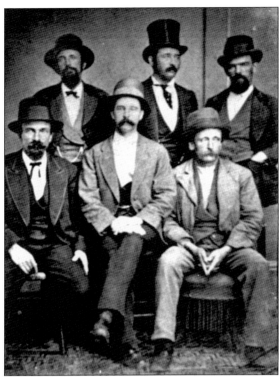

Begun as a town in 1853, Rochelle was known as Lane. These men were prominent for their work on the village of Lane's Board of Trade in 1876. From left to right are (first row) Aaron Cass, Ben West, and Oscar Lake; (second row) James McConaughy, Henry May, and Charles Hotaling. (Courtesy of FTHM.)

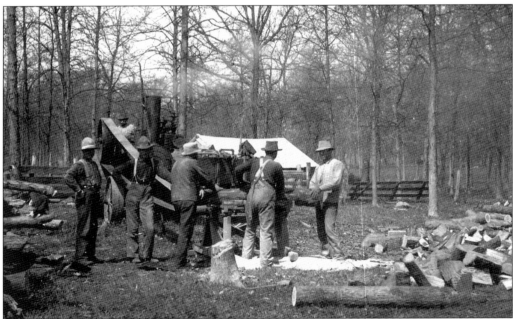

At the back, Elsie Rhodes runs the steam engine while Jay Grimes and Paul Stein feed the saw to the right in 1895. They saw wood for Al Jordon (second from left) on his farm west of Flagg Center. Rhodes was one of the first threshers to own a steam engine and one of the first city of Rochelle engineers at the powerhouse. (Courtesy of FTHM.)

In its early years, Rochelle was world-known for bird hunting. It is said that Queen Victoria's son Prince Albert hunted here. In this 1876 photograph, F. C. Heath, center back, poses with Chicago businessmen after his hunting party has shot its day's kill of prairie chickens. The dead chickens are included in the photograph. (Courtesy of FTHM.)

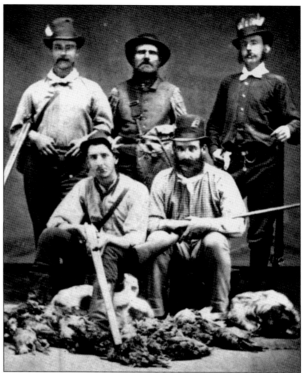

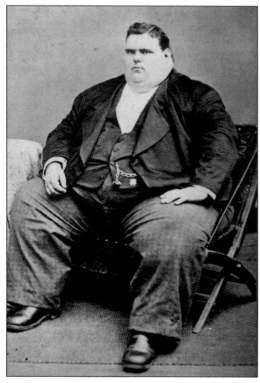

David Navarro Jr. was born June 22, 1861, at a normal weight. Though active, he weighed 440 pounds at the age of 14. In 1876, his parents moved into Lane at Sixth Street and Lincoln Avenue. They accompanied 5-foot-11-inch David when he traveled and exhibited with Barnum Circus. At 735 pounds, he died of pneumonia at age 20 in Pittsburgh, Pennsylvania. His collar size was 24.5 inches; his waist size was 97 inches. (Courtesy of FTHM.)

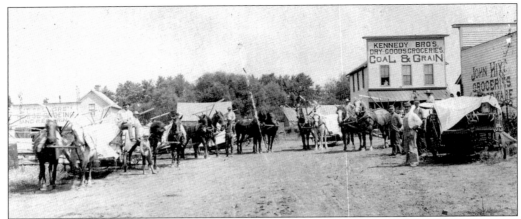

This is the business area of Esmond, a small town north of Rochelle. Michael Garriety, an area farmer, has driven to town in 1885 for his latest purchase of a new McCormick grain binder from John Hix. Garriety's farm was between Esmond and Lindenwood. His neighbors were Robert Pollard, Henry Scamp, John Sharp, John Vogle, and Porter Chamberlain, who owned 1,000 acres. (Courtesy of FTHM.)

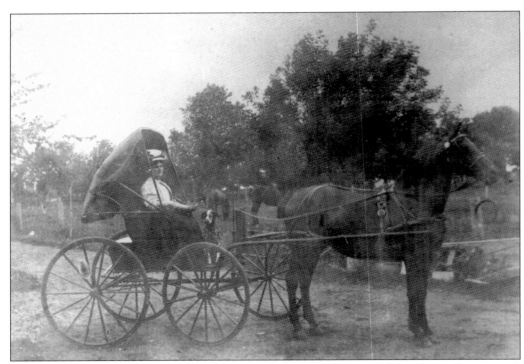

Mrs. Ed Crawford displays the "single rig" with her dog Bruce and her horse Brownie. A horse and dog, who were good companions and company to their driver, were essential in the horse-and-buggy days. The buggy was equipped with a rubber-tired top for the rain and hot sun. (Courtesy of FTHM.)

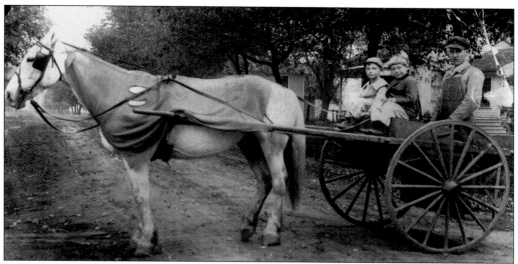

In the early 1900s, meat markets delivered their products via the horse-drawn cart. Archie Morrison is pictured as the driver of the delivery cart. His children sit atop the box, which held the meat and a cake of ice to keep the meat fresh. His horse wears a fly net. (Courtesy of FTHM.)

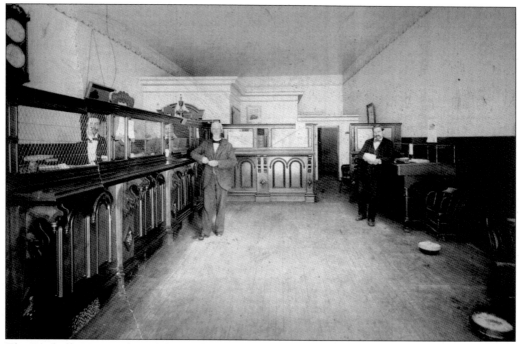

The Rochelle National Bank began business in 1872. I. W. Mallory was president with Francis Carey as vice president. From left to right, Angus Bain stands with his workers, J. T. Miller, Albert Bird, and I. N. Perry. Hinckley Whitman of Chicago and Belvidere established the first bank in Lane during the wildcat currency period, and the bank failed within two years, according to the *Bicentennial History of Ogle County*. (Courtesy of FTHM.)

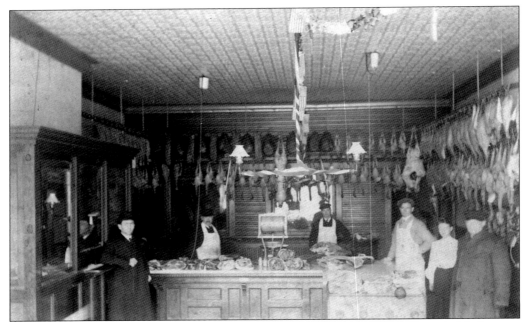

Andrew Binz Meat Market, in the late 1800s, was located on the east side of Lincoln Highway in the 400 block in Rochelle. A customer stands to the left, while J. B. Stevens and Nickolas Binz wait on him. Next is an unidentified worker, then Anna Binz Krug, and Andrew Krug. Note that the skinny chickens hang in abundance while the beef and pork loins lie open on the counter. (Courtesy of FTHM.)

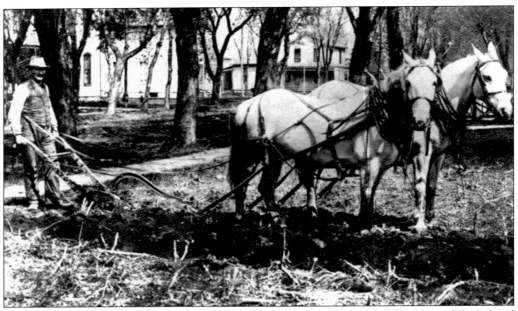

Jim Adair plows the garden on the lot of 507 Ninth Street. The house in the upper middle, behind the horses, belonged to Dr. F. E. Jones. During this era, men who owned horse teams made a good living by teaming (as garden plowing was referred to) in town. (Courtesy of FTHM.)

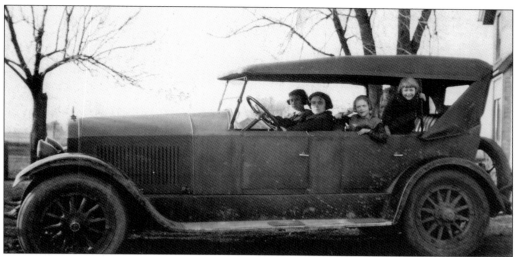

Grandma Mae Tilton is ready to drive her children anywhere. She loved to drive. Notice that the car has no safety restraints or rolled-up windows. She was Ted Tilton's paternal grandmother. (Courtesy of Ted Tilton.)

Caroline Cooper Vaile married E. Galatin Vaile in 1848. Their southeast farm was referred to as Vaile Corner, and they raised Percheron horses and sheep. Their family included five daughters and one son, Dr. David Vaile, a Rochelle dentist. One daughter wedded M. J. Braiden and another wedded Eugene Cole. Their oldest, Mary, lived her life with her parents. Their famous relative was the poet William Cullen Bryant. (Courtesy of FTHM.)

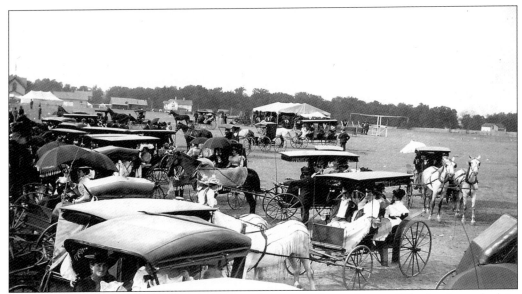

In the horse-and-buggy days, the livery rigs and surreys with top fringe still had to be parked. In the distance, a three-seater transports people. All the horses wear fly nets, some made of leather, and others made of cotton. Most businessmen kept a surrey and an old horse that anyone could use, such as the one in the center with the white fly net that is too short for it. (Courtesy of FTHM.)

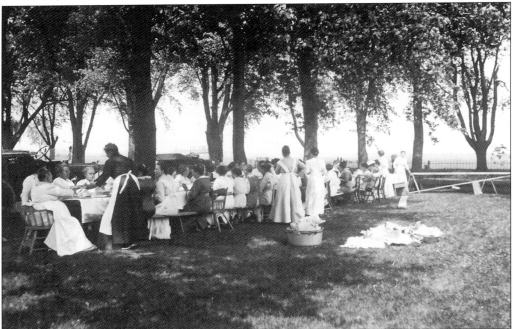

The farm women have fed the worker men on May 19, 1914, and the men have returned to raising the barn on Maplehurst, the Carmichael farm. Now the women can eat and enjoy themselves underneath the shade trees. The barn was built in the distance, beyond the trees. Note the old car in the center. (Courtesy of Leonard D. Carmichael.)

The huge red-brick house at 526 North Seventh Street is known today as Holcomb House and one of three Rochelle buildings on the National Register of Historic Places. William Holcomb built the house in 1872–1873. He had moved his family to Rochelle because as a railroad official, he helped construct the Chicago and Iowa Railroad. He served as mayor and held other leadership positions for 10 years.

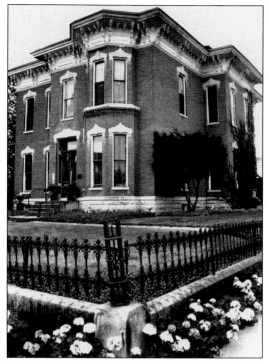

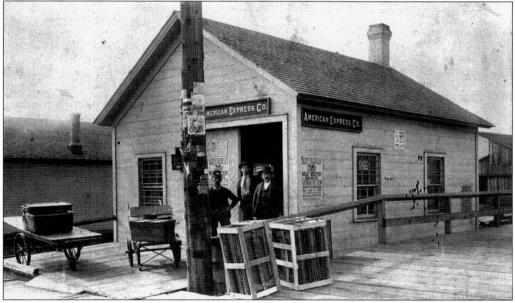

These men, from left to right, are John Beiderstead, a drayman; Henry Henzie Jr., expressman; and N. Parmley, agent. They are standing outside the American Express Company in 1890, which was located on Main Street by the CNW tracks. Later the office was moved to Washington Street near the CBQ tracks and called the Railway Express Company. Before this picture, it was named the American Merchant's Union Express Company in the Colonel May Warehouse. (Courtesy of FTHM.)

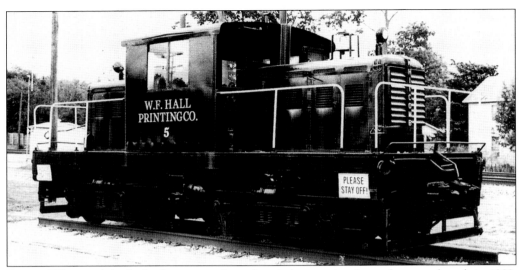

George Whitcomb built the largest gasoline-electric locomotive for underground work in 1929. Then he built the diesel-electrics, which revolutionized the American transportation system. This switching locomotive, located in the Railroad Park, is one of the locomotives manufactured in Rochelle. The last Whitcomb locomotive—a 25-ton diesel-electric—was shipped on January 4, 1952. The Whitcomb Locomotive Company built around 5,000 units. The company also built cars, including the Partin-Palmer car. (Courtesy of Marie O'Connor.)

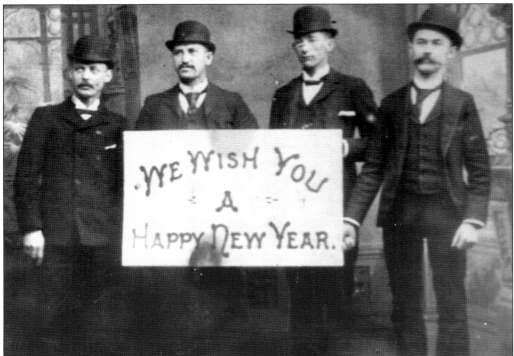

From left to right are Mr. Koefer, Burr Sheadle, Dr. Ed Vaile, and Mr. Vorman. All but Vaile were CNW Railroad office employees while in Rochelle. They posed for their new year's photograph. The new year was 1891. (Courtesy of FTHM.)

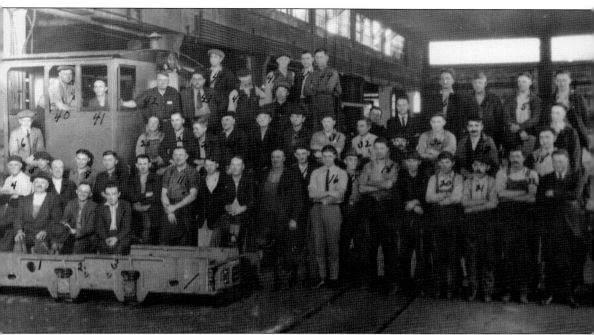

This 1920 photograph shows some of the employees at the Whitcomb Locomotive Company. A list of some individuals are (first row) Roy Baker (7), Charles Woodrick (11), Earl Onley (12), James Walker (13), George Kramer (14), Rasmus Johnson (19), Jim Hannan (20), Otto Stangley (21), and Leonard Caspters (22); (second row) Roy Johnson (6), Oscar Porter (27), Jack Lawton (28), Jim Doner Sr. (29), Charles Osbourne (31), William Stopple (34), and Fred Wollocott (37); (third row) Claude Pinkston (42), Gus Degryse (46), Fus Lewis (50), Carl Marksman (52), and Carl Grieve (53); (fourth row) Banks Phillips (47), Carl Rhodes (48), and Stanley Bauder (49). In 1878, George Whitcomb designed and marketed the first successful coal mining machine. He moved his plant from Chicago to Rochelle in 1907 to build larger quantities of gasoline-powered locomotives for coal and metal mine operation. Whitcomb designed the first explosion-proof electric mine locomotive in 1914. The first Whitcomb electric trolley locomotive was produced in 1921. (Courtesy of FTHM.)

Joseph K. Updyke, born in 1847, moved to Rochelle in 1872 and resided there all of his active life. In earlier years, he had designed depots for the CNW Railroad. Many old, local buildings are his designs, such as the Masonic temple at 500 Lincoln Highway. He was a member of the Odd Fellows and the Modern Woodmen. He died on September 15, 1934, in Chicago. (Courtesy of FTHM.)

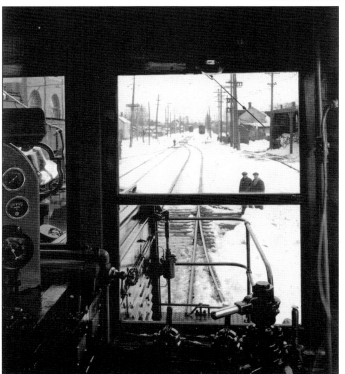

This view is from inside the train's engine around the 1930s. The train is a diesel. From the track sight, the train must be parked on a side track. This must be a parking area for trains because of the various tracks. How nice it is to see a snow picture. Down the line, a person stands, possibly, to take a picture. (Courtesy of FTHM.)

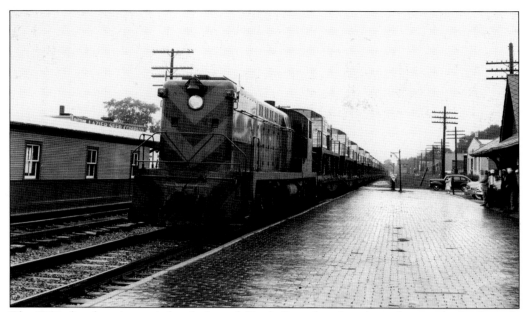

The 1950s diesel-engine train heads through Rochelle with its long line of cargo of cabs. A single engine powers the train, unlike today when at least two are needed. Antique cars of today wait at the crossing. To the right is part of the new depot built in 1921. The Lazier Seed Company was located on the other side of the second track. (Courtesy of FTHM.)

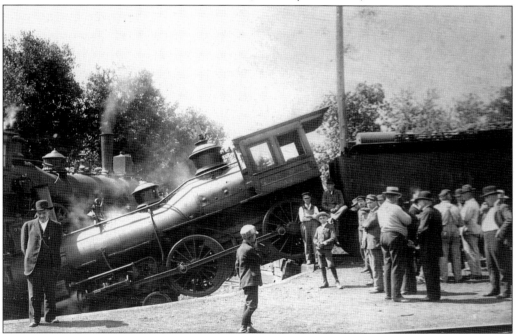

This collision occurred on the south side of the CBQ tracks, on the east side of Seventh Street crossing. A switch had been left open. Notice the turntable underneath the engine. The Rockford train's engine ran into the open turntable, while the Forreston train engine was turning. This photograph is taken from the north. (Courtesy of FTHM.)

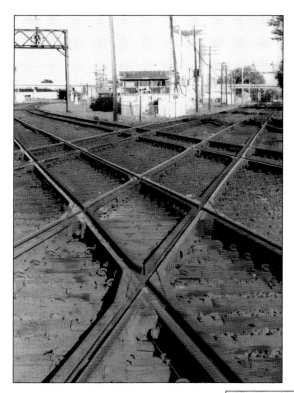

Seen at Railroad Park, this is a close view of the more elaborate diamond, which is made from the crossing of the seven different railroad companies' tracks—CBQ, BNSF, Union Pacific, Southern Pacific, Burling Northern, Santa Fe, and Canadian Pacific. Handicapped-accessible, the Railroad Park has visitors from many states and foreign countries to view operating trains. Train traffic is approximately 120 trains daily. (Courtesy of Denny and Sue Golden.)

When the CNW office was located in Rochelle, H. D. Judson was in charge of the workplace. The office was located in the Bain building. Many years passed before the head office was moved to Aurora. Judson poses with his wife and children for a family portrait. (Courtesy of FTHM.)

Three

THE BUSINESS OF ROCHELLE

Lane's first business was located in part of William Cochrane's log cabin.

With the railroad, the downtown district was established on Main and Washington Streets. The first store, The Shades, was owned by the Johnson brothers and sold groceries.

In 1861, Peter Unger started the furniture and funeral business. When Unger's sons, George and Charles, continued the company in 1891, embalming became the practice. In the 1930s, furniture was discontinued. When Charles' son-in-law, Fred F. Horner, came into the business, funerals were held in a central building rather than in a person's home. Fred's son, Don, purchased the business in 1966, marking the fifth generation to run the business. Many of Rochelle's early photographs and memorabilia are displayed in the funeral home.

The Shockley building, better known as "the old corner brick," was "the pride and joy of Rochelle," according to the *Rochelle Centennial Souvenir Program*. In 1904, Baxter and Hathaway modernized the building for the People's Loan and Trust Company.

Emanuel Hilb started the Hilb and Kline Clothing, which became the Carney and Longenecker Clothing store in 1907.

The O. J. Caron yarn business was located in Rochelle in 1915.

The first canning plant began operation in 1904 with sweet corn as its first product. P. Hohenadel Jr. managed the plant. After several owners, Del Monte purchased the canneries in 1967.

Swift and Company joined the city in 1960 as a modern meat-processing plant and provided 500 jobs.

Four generations of Tilton families have built Rochelle since 1852. Elijah Tilton and his son William farmed and established the Tilton Livery Barn in 1893. Clarence Tilton began the first roller rink. Floyd Tilton practiced general law in Rochelle. Other Tiltons went into banking. The John W. Tilton industries acquired construction companies. John W. Tilton also purchased the newspaper, and his first issue of the *Northern Illinois Democrat* was published on February 9, 1953.

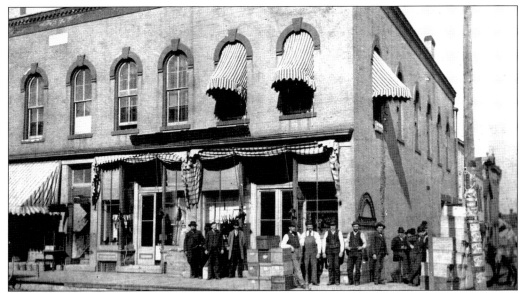

The Shockley building was constructed in 1870–1871. In this early 1880s photograph, those identified are, from left to right, Ernie Spaulding, C. Berry, Mr. Vorman, A. Fields, W. Hurd, Gidion Williams, George Spaudling, and Ben Thornburg. Edward Fields leans against the crates to the right. The others are unidentified. Francis Glenn and Company (general store) was one of the first businesses in the building. The telegraph pole supported the lines to the railroad depot. (Courtesy of FTHM.)

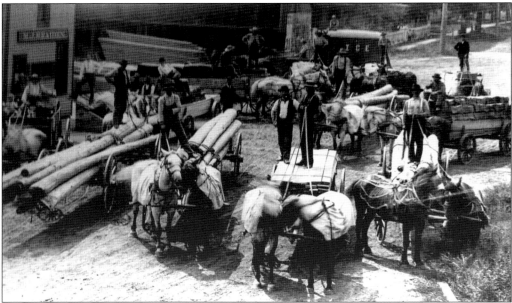

In 1895, Lindenwood farmers haul lumber for Joe Murphy to construct a machine shed. In the vest and white shirt on the center load is John Varner, yard foreman. To the left, Fred Craft, manager and bookkeeper, stands on the coal box. M.J. Braiden—in a suit—is on center ground. Hugh Murphy stands on the wagon to the right, and Joe Murphy stands on the wagon to the left. (Courtesy of FTHM.)

Floyd Countryman poses for his high school graduation portrait. The Countrymans settled around Lindenwood in 1855. Daniel Countryman brought his wife and four children from New York State to farm. Daniel's son, John Alonzo, started the purebred Shorthorn cattle in 1880. His grandson Floyd, then Floyd's son Frank, continued the business. Floyd was born on the homestead in 1874. They were cousins to the other eight Countryman brothers. (Courtesy of FTHM.)

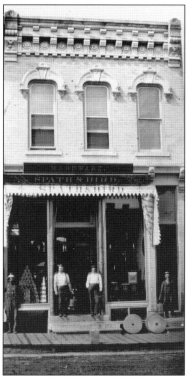

Joe Spath, a tinner, stands in the doorway to the left, holding an old style of tinner's furnace. His partner beside him is George Bird. Spath remained at the location as long as he ran the business. Note the grindstones in front for sale and the outside entrance to the left to the basement. William Healy had originally constructed the building in the early 1870s. (Courtesy of FTHM.)

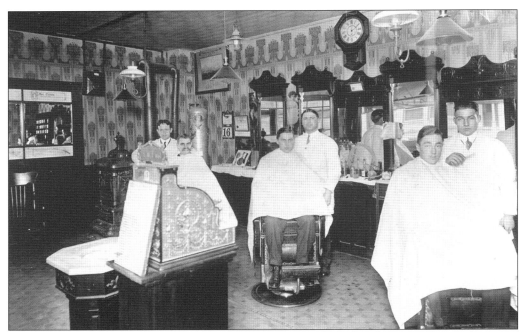

In this late 1800s photograph of an early barbershop, Albert M. Lind, barber, poses at the far left with his customer, Jim DeCourcey. Barber Fred Poole is the middle man. The others are unidentified. The shop was located in the 400 block of East Lincoln Highway. Notice the intricacies of the shop, especially the rack of mugs in the mirror's reflection at far left. (Courtesy of Flagg Township Historical Society.)

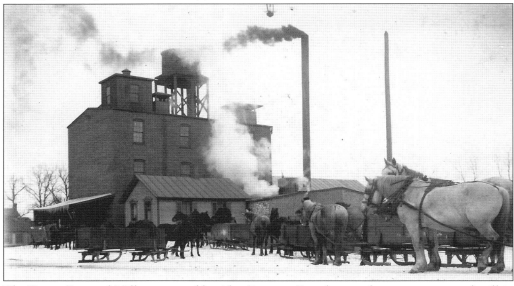

The Forest Oatmeal Mill was owned by Alex Forest, a Scotchman whose water-powered mill in Oregon had burned in 1878. This 1892 photograph shows the Rochelle mill run by steam, and it burned in the late 1890s. The Norman horses denote prosperous farmers. Milling-quality oats had to test 32 pounds to the bushel or better. Otherwise, they were used to feed stock. Notice the sleds that the horses pull. (Courtesy of FTHM.)

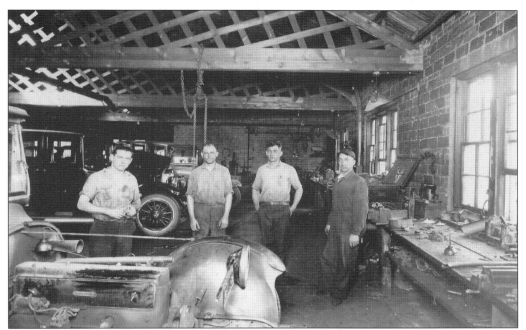

Bob Lazier owned a garage to repair automobiles (as people called their cars back then). In the photograph, notice that the early 1900s automobile was uncomplicated compared to the computerized engines of the 21st century. Lazier stands to the left; the other people are unidentified. (Courtesy of Ted Tilton.)

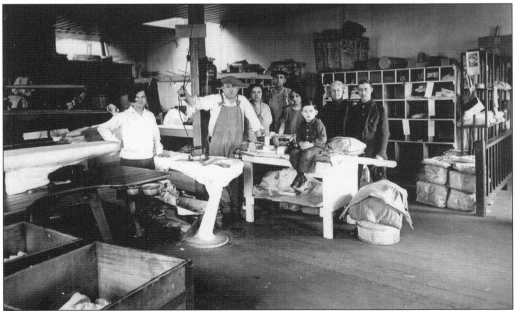

The Rochelle Laundry was begun in the early 1900s. The people in the photograph are unidentified. The walls and surroundings connote a basement room. The woman to the left appears to wear dressy shoes and probably was the office clerk. Laundry was paper-bundled in those days. (Courtesy of FTHM.)

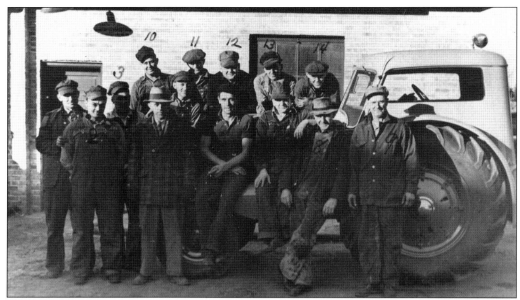

This photograph of the Del Monte farm shop gang was taken in 1942. Seen here are, from left to right, (first row) Henry Hendricks, Ray Alcock, Earl Tilton, Howard Heltness, Clyde Schanenberg, Chuck Mau, Earl Sharp, Walt Klewin, and George Bearrows; (second row) Dick Cotheron, Percy Mickley, Earl Phillips, Ernie Lockridge, and Earl Riddle. (Courtesy of FTHM.)

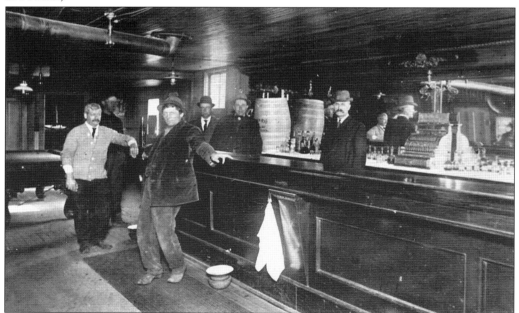

Seen here is the interior of an early 1900s saloon on Cherry and Main Streets. Situated in the old Bowler building, Mike Vaughn, behind the bar, owned the establishment. Jimmie Ray, Vaughn's bartender, is seen in the sweater. The man behind him is unidentified. Leaning against the bar is a regular customer "Coxy" Misner. The other men at the back are Ole Olson (left) and Clint Myers (right). (Courtesy of FTHM.)

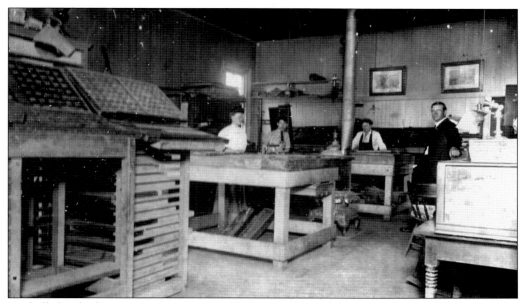

Rochelle has had a newspaper since 1858. Prof. James Butterfield started the *Lane Patriot* in 1861. E. Otis of Rockford took over the old equipment and rolled out the first copy of the *Lane Register* on July 25, 1863. Other names have been *Rochelle Register, Rochelle Independent, Rochelle News, Rochelle Herald,* and today, the *Rochelle News Leader.* No one in this photograph of the Rochelle Register's office is identified. (Courtesy of FTHM.)

Harry "Snap" Sammons leans against the doorway of his barbershop on Cherry Street, around 1900. He had learned his trade from Mr. Porter, an African-American barber in Lane for many years. When he ran his own shop, Porter allowed no swearing and cleverly influenced his customers never to swear a second time. Sammons later moved his shop, and the Sullivan brothers opened a cigar store in his place. (Courtesy of FTHM.)

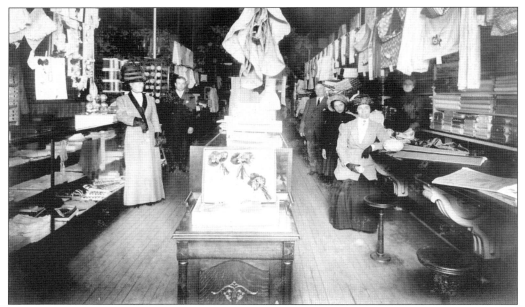

In the early 1900s, G. W. Hamlin owned a dry goods store on Lincoln Highway. The department pictured was obviously linens and women's items. Jack Larkey, left, was a clerk for several years. G. W. Hamlin stands to the right. Behind the counter is Miss Blanche Tilton, a clerk who worked all the years Hamlin Dry Goods was in business. The customers are unidentified. (Courtesy of FTHM.)

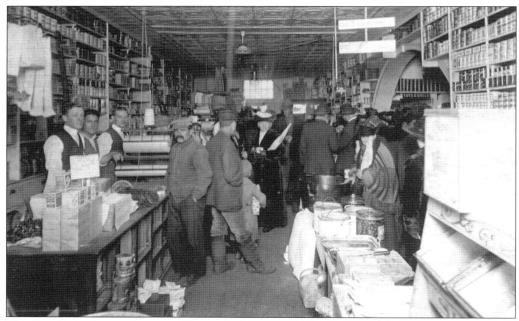

The Rae E. Anderson Store on Cherry Street contained a variety of departments in which to shop. This photograph displays the grocery area, which was on the east side of the store. The clerks are, from left to right, George Colath, Martin Herrmann, and Fred Larson. Apples sold for 50¢ per dozen. (Courtesy of FTHM.)

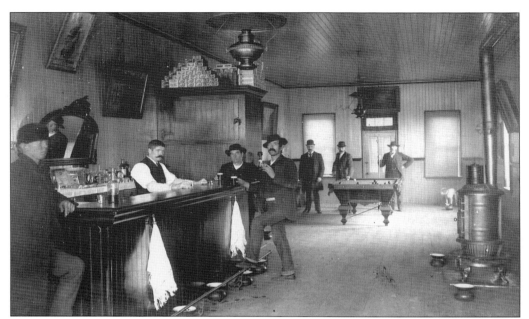

Not all saloons were on Cherry Avenue. In 1888, the Mike Hayes Saloon was located on the west side of Main Street, south of the railroad tracks. From left to right stand Tom "Sawhorse" Peterson; William P. Hayes, bartender; Tom Delaney, grocery store clerk; Frank Freeland, blacksmith; Phil Sullivan, Chicago policeman; Jack McDermott; and Mike Hayes, owner. The dog is unidentified. Note the many spittoons. (Courtesy of FTHM.)

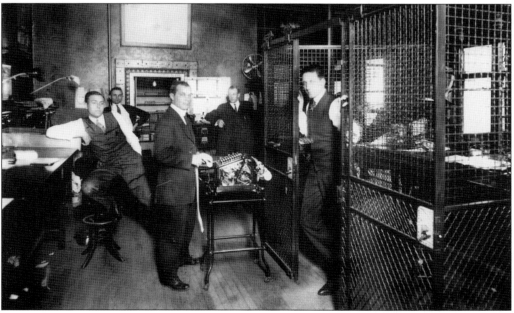

The interior of the old Rochelle Trust and Savings Bank was located at the corner of Fourth Avenue and Lincoln Highway. In the foreground is Hurley Reed with Charlie Healy in the cage's doorway. Joe Olson leans at the left, with Arthur T. Guest (left) and Walter Pickle (right) in the background. (Courtesy of FTHM.)

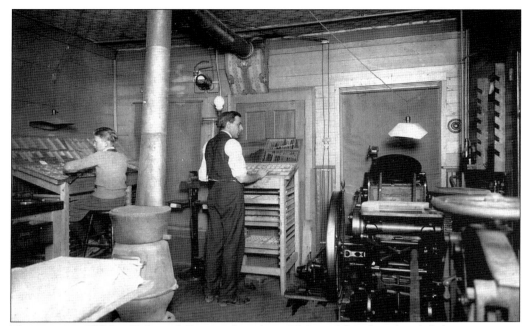

The interior of Walter Hohenadel's print shop shows Hohenadel at thought while his apprentice, Hale Weeks, sits at the case to learn to set type. Weeks would work on Saturdays and after school. Through time, Hohenadel's small business grew into the Hohenadel Printing Company, located on Dewey Avenue. His assistant chose another vocation. (Courtesy of FTHM.)

Eliga Taylor's butcher shop sat on Cherry Street in Hickory Grove. He owned grazing land east of town. When needed, Taylor drove a wagon, pulling a saddle horse, to the herd. Then he mounted the horse, shot a steer, dressed it, and hauled the meat to town. He and his wife had two daughters and a son, Will, who practiced law until he moved west. (Courtesy of FTHM.)

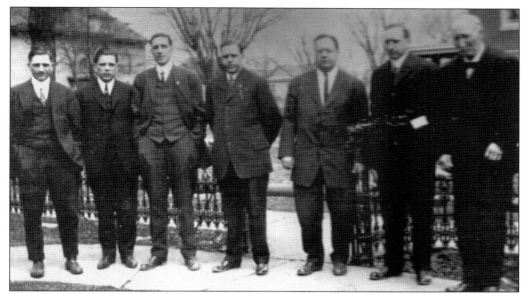

Seen here are William Healy (far right) and his six sons, listed from left to right, William, Frank, John, Charley, Winfield, and Carleton. Their respective nicknames were Bill, Boliver, Boomer, Chick, Win, and Cop. William came to Rochelle in 1871 and was born on March 14, 1846, in Ireland. He married Mary McDermott on November 23, 1876. He ran a grocery and bakery store and later a liquor business. Their home stood at Seventh Street and Fifth Avenue. (Courtesy of Flagg Township Historical Society.)

Wells Atwater, son of A. K. Atwater, ran his father's classy restaurant, which was started on Cherry Street in 1870. He sold the business to Fred Larson and purchased a dry goods store from Billy Williams. Later he was employed in Harry Hall's grocery store. He and his wife, Alice Carey, are shown with three of their four children, Ruth, Arthur, and Pauline. David, the fourth child, was born later. (Courtesy of Flagg Township Historical Society.)

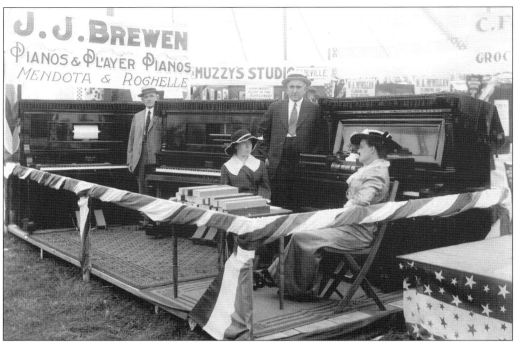

Around 1900, John Brewen (center) relaxes at the fair among his display for his music stores in Rochelle and Mendota. With its large gatherings, the fair was an opportune time to advertise a business under a large tent. Lulu Menz (left) and Bertha Miller are his helpers, possibly to demonstrate the player pianos. The man in the back is unidentified. (Courtesy of FTHM.)

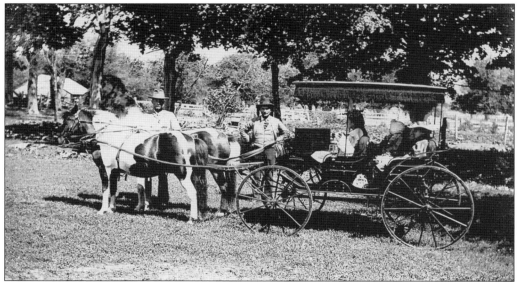

George Steele (left) was the owner of the farm west of Rochelle. The farm was known as Pierce farm. Steele was noted as a raiser of Shetland ponies. The man in the suit and his children are unidentified. The family readies for a ride in a surrey with the fringe on top. Notice the baby with its cute bonnet in the back. Hats and bonnets were that day's fashion. (Courtesy of Flagg Township Historical Society.)

Originally the Exchange Bank of Holcomb in 1892, Holcomb State Bank's first president was W. D. Oakes. The photograph shows the branch bank in Rochelle at 233 East Highway 38. The bank's notoriety comes from being one of three Ogle County banks to survive the great depression. Its staff also survived a 1936 security test when robbers shot machine guns at the bank's bullet-proof windows in Holcomb. (Courtesy of Marie O'Connor.)

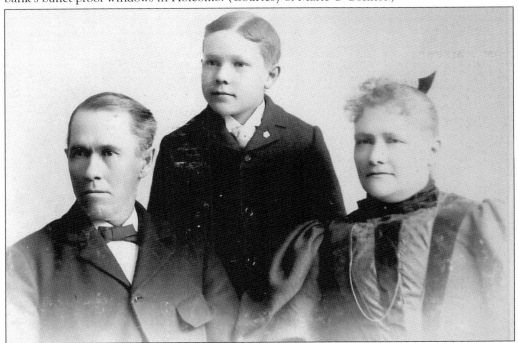

Mr. and Mrs. Henry Loomis sit with their son Howard in the late 1800s. Henry belonged to Loomis and Pierce Lumber Company and later to Milne and Loomis, a lumber and coal company, which was located where Patterson Lumber Company was. Their house was built on the west end of Avenue D, where the first tee of the golf course lies. Later it was moved to 500 South Main Street. (Courtesy of Flagg Township Historical Society.)

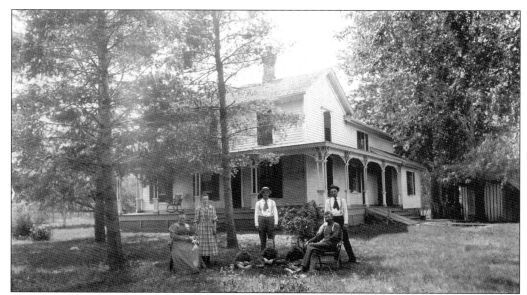

This house is where Leonard D. Carmichael was raised. During the potato famine in 1849, his grandfather James—age one month—traveled three months by ship from Ireland to America. In the 1850s, James, 10, and John, 13, traveled west on the famed Orphan Train. John eventually moved to Nebraska. In 1873, James married Alma Knight and purchased the farmland on Moore Road in 1877, today known as Maplehurst. (Courtesy of Leonard D. Carmichael.)

During the summer of 1914, James Carmichael stands among his shorthorn cattle at Maplehurst, the name of the family's farm homestead. That spring, the neighbors had held a barn raising, and that barn can be seen to the left. James and Alma Carmichael were the grandparents of Leonard D. Carmichael, who now owns and lives on Maplehurst. (Courtesy of Leonard D. Carmichael.)

Otto Wettstein opened his first jewelry store in Lane in 1858 on the north side of Cherry Avenue at 418. In 1863, he moved his business to the brick building, constructed in 1854 on the south side of Cherry Avenue, which was later known as the "corner brick." Eventually he sold his business to William Hackett. (Courtesy of FTHM.)

William Hackett and his wife pose for their formal portrait in the late 1800s. He started Hackett Jewelry Store in 1899 from his purchase of the Otto Wettstein Jewelry Store. A jewelry store remained at that same location until 1971. William Hackett served the public for 54 years and was a clerk in Wettstein's store. (Courtesy of FTHM.)

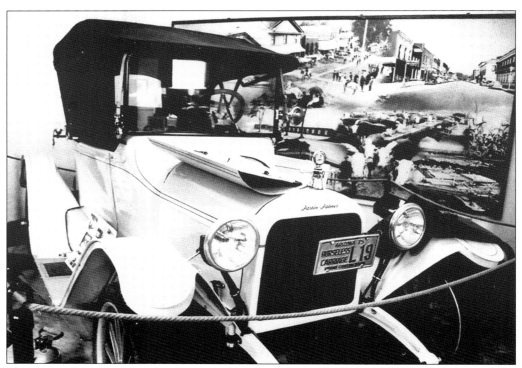

The Partin-Palmer car in the photograph was purchased for $30,000 by the Flagg Township Historical Society to restore and is displayed in the museum. No other Partin-Palmer car is known to exist. In 1915, the George D. Whitcomb Company in Rochelle was chosen to assemble the car. The Whitcomb Company had also produced engines and electrical mining equipment. (Courtesy of Marie O'Connor.)

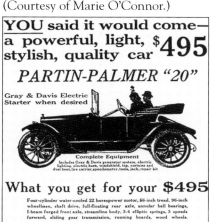

Partin-Palmer cars were built for only four years, starting in Chicago. In April 1915, the assembly took place in Rochelle. The new 20 horsepower, model 20 roadster originally cost $495 and was a forerunner to the Checker taxicab, built in 1920. The company also manufactured a model 38 touring car for $1,000. (Courtesy of FTHM.)

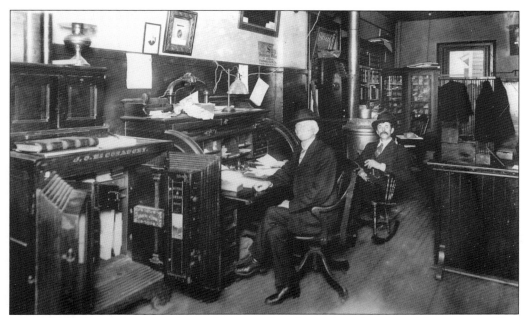

James O. McConaughy sits in his real estate office, from where he also sold insurance. Glen Bothwell sits in the rocking chair. McConaughy arrived in 1854 and purchased the Lane farm. He plotted three additions of 40 acres to the city and built many private homes, such as his own, Greenhurst. He and his wife had a son Edward, an attorney, and two daughters, Mrs. Clarence Tilton and Mrs. Phil May Sr. (Courtesy of FTHM.)

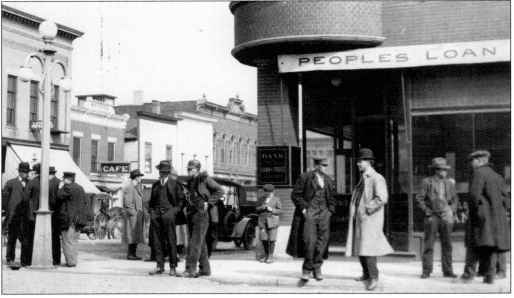

The People's Loan and Trust Company was on the corner of Cherry Street and Lincoln Highway. The People's Loan and Trust Company was founded in 1899 by James Fessler, Thomas Keegan, M. Hathaway, J. Weeks, Howard Cooper, and Arthur Phelps. Taken in 1916, the photograph shows a "CAFE" sign on the William Hayes building that belonged to John Sweeney. Later he became proprietor of the Corner Drug Store. (Courtesy of Flagg Township Historical Society.)

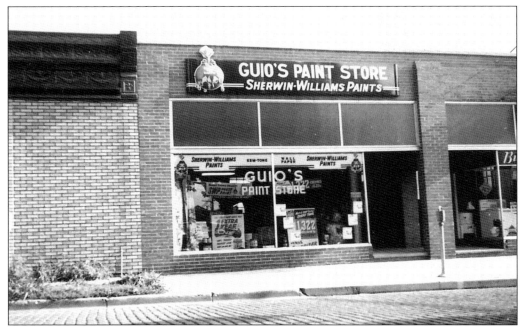

For some years, Elmer and Grace Guio owned and operated Guio's paint store on Sixth Street with Bunger's Appliance to the right. The store was a successful city business until 1957 when the Guios decided to return to teaching. Grace Guio taught at the Tilton School, and Elmer Guio trained high-schoolers in industrial arts and taught history classes. (Courtesy of John Guio.)

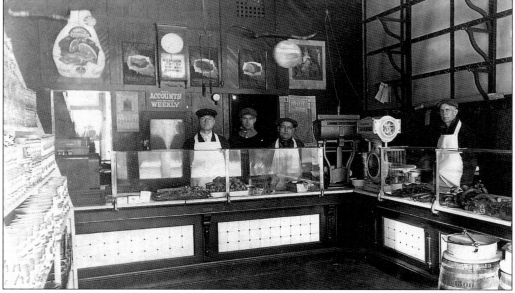

From left to right stand John Schick, Art Conner, Leo Carr, and J. E. Conner in Taylor's Meat Market in 1919. The business had formerly been Cooper's Market on Cherry Avenue. Notice that the meat is stored behind glass fronts, compared to earlier years when it was displayed on counter tops and hanging from the beams. (Courtesy of FTHM.)

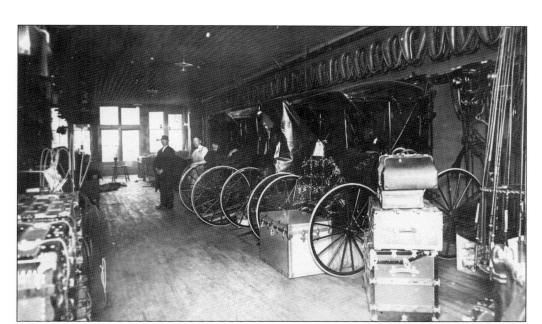

The Unger Harness Shop stood on the west side of Lincoln Highway. Bart Unger was the last of the harness makers in Rochelle. Note the plethora of leather products, from bags to horse collars. Objects on the right look like fishing poles; above the rigs are several horse collars. The people are unidentified. (Courtesy of FTHM.)

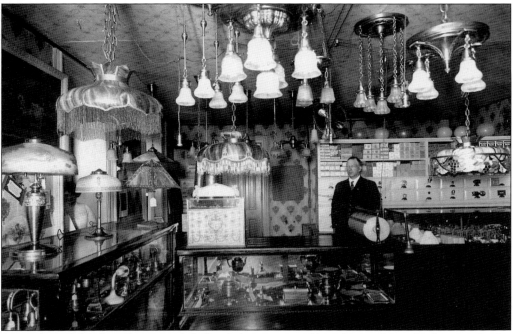

Around 1915, Herbert Bain stands behind the counter of his electrical supply shop inside the main entrance to the Bain building. Notice the stained-glass hanging light, the fringed lamps, and the small, white ceiling lights, all in fashion today. The other beautiful lamps are found in antique stores. (Courtesy of FTHM.)

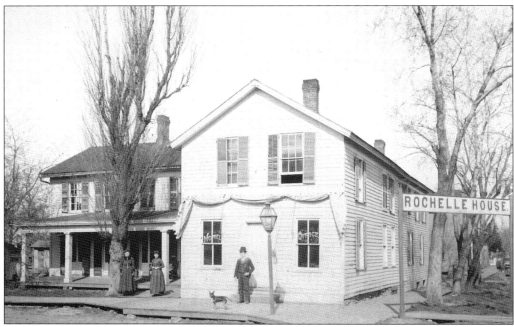

J. E. Barber arrived in Rochelle in 1884 and took over the management of the Rochelle House. Two years later, he sold his interest to Frank Bishop. The old building later was removed, and the Collier Hotel was built upon the site. None of the people in the photograph are identified, including the dog. (Courtesy of Flagg Township Historical Society.)

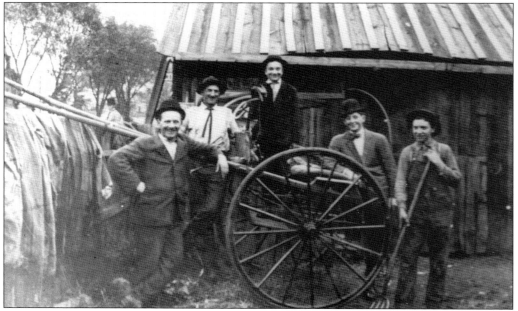

The gang at the McMann Livery Barn gathered behind the stables around one of the horse carts for a photograph in the late 1800s. From left to right are Red Westphal, Jasper Lawson, Steve Dee, George McMann Jr., and stable boy Charlie Allen. The man in the top hat in the left background is unidentified. (Courtesy of FTHM.)

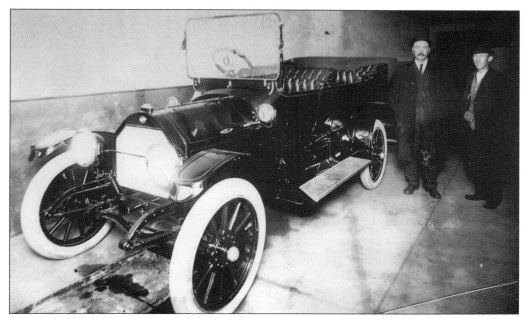

In the early 1900s, James Sherlock and his brother John (right) stand beside the new Overland car at his automobile business on the west side of Washington Street, across from the Patterson Lumber Company. Sherlock later ran his business out of the Mike Hayes building. He changed his dealership to Buicks and finally constructed his own building at Sixth Street and Lincoln Avenue. (Courtesy of FTHM.)

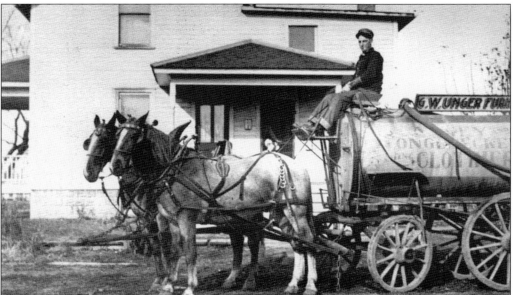

Walter Kennedy sits atop the city water wagon. The business was owned by Al Robins. The city owned the sprinkling wagon. Each year, local men with horse teams contracted with the city to furnish water to keep the roads dust-free. Prior people who had worked the job were "little Jimmie" Boyle, George Onley, and Jim Adair. George Unger Furniture and Carney and Longenecker Mens Clothing Store kept their signs freshly painted for each season. (Courtesy of FTHM.)

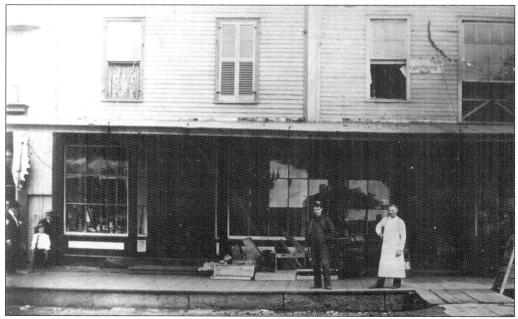

Around 1900, Fred Larson Sr. ran a restaurant and variety store on the south side of Cherry Street. His clerk—to the left of Larson—was Albert Nelson, Art Nelson's father. In the earlier years, the store owners displayed some merchandise outside. Later Al Taylor ran a cigar factory upstairs. (Courtesy of FTHM.)

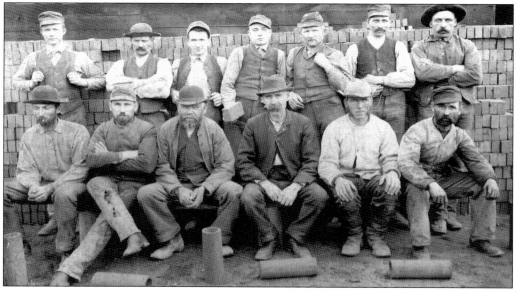

The Rochelle Tile Factory employees are seen in this image from 1880. William Stocking and T. Southworth Sr. owned the company, which was later purchased by Patton and McHenry. At the back left is Hugh Carmichael, whose father worked for Braiden Lumber. Sam Hansen is second from the right in the second row; he was the Central School janitor for years. Beside him, to the right, stands Con Henderson. Notice the tiles at their feet the employees had made. (Courtesy of FTHM.)

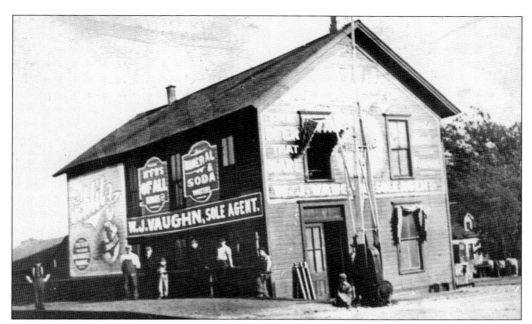

Even back in the 1800s, companies used sides of buildings to advertise their names, as they did on the Rochelle Bottling Company building. The building was situated on the south side of the CNW tracks. William Vaughn ran the business. The house to the right belonged to the Winders family. Rochelle had 14 saloons at that time. (Courtesy of FTHM.)

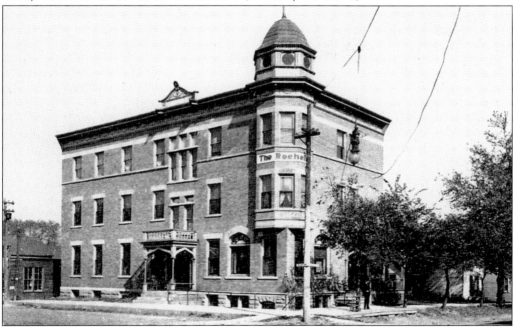

The Rochelle House, a 1900s hotel, stood on the northeast corner of North Main Street and Cherry Avenue. It was built in 1899 and later renamed the Collier Inn. Originally a wood hotel, Baxter House had stood on the corner. When the village of Lane was renamed to Rochelle, the owner called the hotel the Rochelle House. The building was demolished in 1989. (Courtesy of FTHM.)

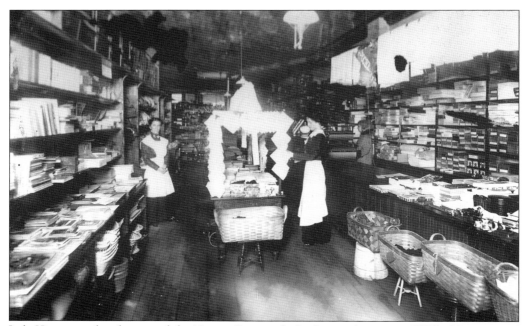

Lulu King owned and operated the Variety Store with the financial interest of Willis Houston and his sister May. King stands on the left in the store, located on the west side of Lincoln Highway. Catherine Lewis, her clerk, arranges linens on the right. The Lang Grocery Store was located next door to the north, and the Brewen Music Store was to the south. (Courtesy of FTHM.)

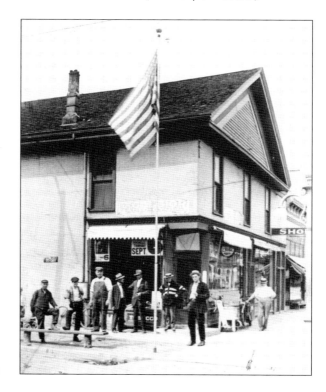

The B and L Restaurant occupied the corner of Lincoln Highway and Fourth Avenue. Prior to that, a bicycle and electrical shop, owned by Al Taylor, was located there. The 1915 photograph was taken before the young men left for World War I. From left to right are Wilbur Antoine, Maynard England, Ross Harter, Bill Wheeler, Lawrence Smith, Al Taylor, Walter "Squeak" Vierke, and Morris Kahler, who ran the shoe store. (Courtesy of FTHM.)

Four

SOMEWHERE IN THE CITY

As Lane matured, the city built a bridge across Kyte River for $300. Small but essential items were paid. On June 14, 1872, Peter Unger was paid $16 for the coffin of someone killed on the railroad. N. Tracy was paid $3 on October 11, 1872, for digging a grave for Mary Hudson. Her coffin cost $20.

A half percent property tax was levied to support each Civil War volunteer's family. The general monthly cost was $3 per wife and $1 for each child under 14.

On February 1, 1865, a special election voted on a bounty tax to defray the expenses for the president's last call for Civil War volunteers. The vote passed 197 to 3.

In 1866, Flagg Township voted for a tax of $3,000 to build a town hall for Lane, as long as Lane paid the same amount. It did not. In 1869, the township purchased two lots for a town hall, but again the city was against the offer. The city officials wanted to purchase the old Methodist church for $450 for a town hall, but the township voted against that building in 1882. The city hall was finally built in 1884 and remains today as the Flagg Township Historical Museum and is on the National Register of Historic Places.

The county jail was constructed in 1839. A two-story, stone-and-wood edifice, it cost $1,822.50. The wooden second story held the office, and the lower stone level contained the cells. A trap door to the cells led down a ladder. Once the prisoner was in the cell, the ladder was hoisted out.

With the help of Laura Fessler, Charles Joiner, Rochelle public schools superintendent, pressed the state to adopt a state tree and flower. As a result, school children voted on their favorites. The winning tree was the oak; the flower, the violet.

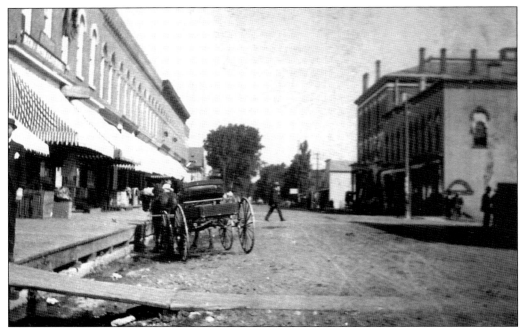

The dirt streets with wood walks and someone's horse and buggy create a quaint yesteryear photograph of the Shockley building (left) and Bain Opera House (far right). In 1872, the citizens requested a referendum to incorporate Lane, under the new state constitution, as a city rather than a village. The referendum passed 124 to 49 on September 10, 1872. However, voters refused minority representation in the state's house of representatives. (Courtesy of FTHM.)

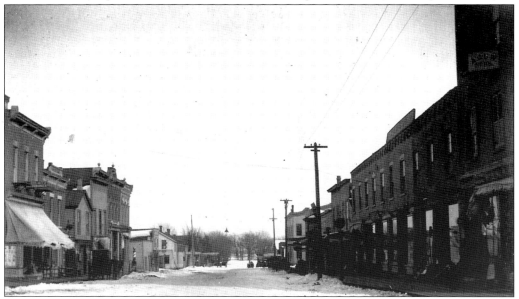

Few winter photographs were found in the Flagg Township Historical Museum. This one depicts downtown Rochelle in the winter in the late 1800s. The shops' summer awnings are neatly rolled up or taken down, although the one on the left looks a bit tattered with icicles. The wood walkways are clearly shoveled. Notice the old barbershop pole. (Courtesy of FTHM.)

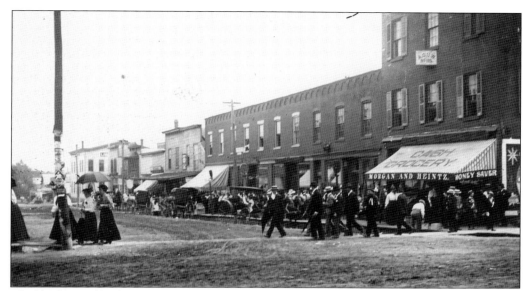

The three-story building on Cherry Avenue was known as the "old corner brick" about 1893. McMann Livery Barn and the Holcomb Farm Machinery Warehouse can be found in the distance. The Morgan and Heintz store was a real money saver, according to its sign. The sidewalks were wooden planks with unpaved roads. (Courtesy of FTHM.)

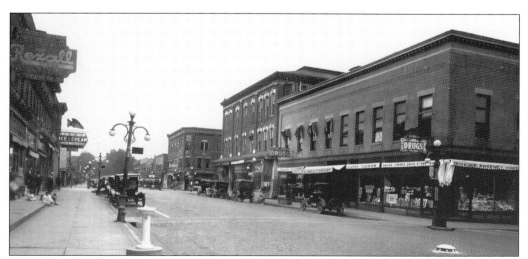

This is the corner of Washington Street (Lincoln Highway) and Cherry Street (Avenue) in the early 1900s. The stores were mainly for the drug business, with the exception of ice cream. Note the quaint, street-light fixtures that are similar to restored, present-day sections of cities. Most cars carried their spare tires on the back. (Courtesy of FTHM.)

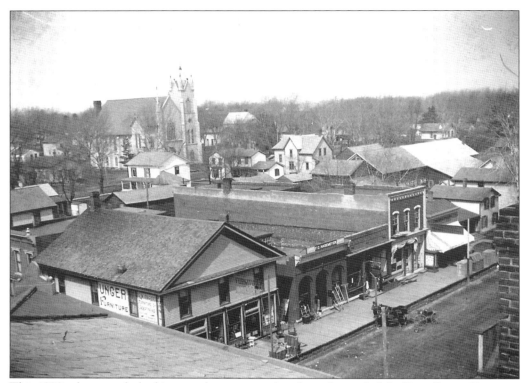

This 1890s photograph, looking northwest, was taken from the roof of the Bain Opera House on Washington Street. The church in the background is the Presbyterian church built in 1875. The Unger Furniture Store was housed in the first Methodist church building, which was moved in 1882 when the congregation built a new church. (Courtesy of FTHM.)

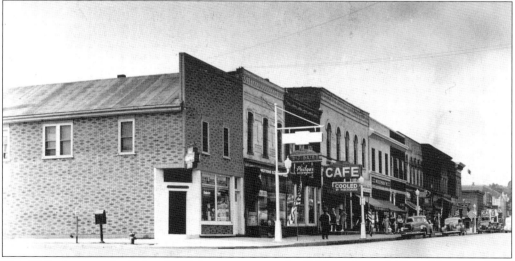

This 1941 photograph of Lincoln Highway contrasts the 1800s to the mid-1900s. The styles have changed, and the city has been cleaned up. Streets now have electrical lampposts and curbs and are paved. The automobile is now the mode of transportation. Notice the American flags displayed along the street. (Courtesy of FTHM.)

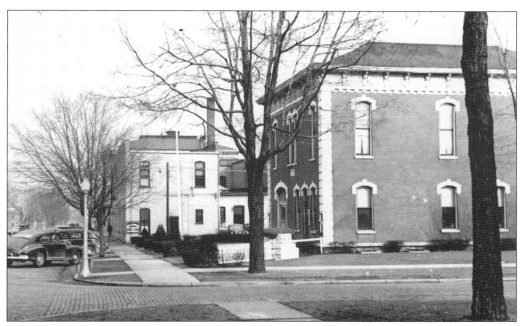

While Angus Bain was mayor in 1884, a town hall was built jointly by the city and the township. Alderman Sam J. Parker sketched the building, and Bradley and Son designed it. John Steele, a local contractor, constructed the red brick building for $6,200. Thick wooden planks served as sidewalks with hitching posts and rails for horses and mules on the east side. The building is on the National Register of Historic Places. (Courtesy of FTHM.)

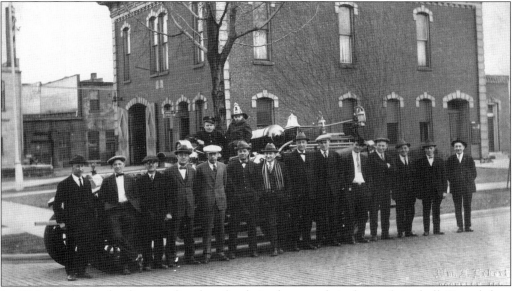

In 1915, firemen and policemen lined up for their photograph in front of city hall. From left to right are Wellington Taylor (truck driver), John Maxson, Remy Hydecker, Bill Wheeler, Bill Caspers, Nick Binz, Art Hamaker, "String" Henzie (fire chief), Walter Vierke, Art Wood, Russell Hainaker, John Swartz, Scott Rice, and Joe Unger. Charles Ludwig sits on the truck with Nick Binz's son. (Courtesy of FTHM.)

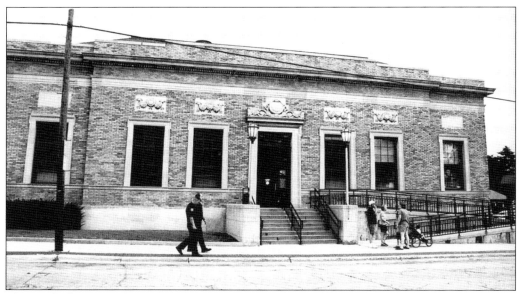

The Rochelle Post Office was built in 1914, located at Lincoln Highway and Fifth Avenue. In 1854, Lane built its own post office at today's intersection of Route 251 and Flagg Road. David Stiles was its first postmaster and had also run a general merchandise store. Sue Comins retired May 3, 2006, as its latest postmaster. This photograph shows two of Rochelle's finest during the August Heritage days, 2006. (Courtesy of Marie O'Connor.)

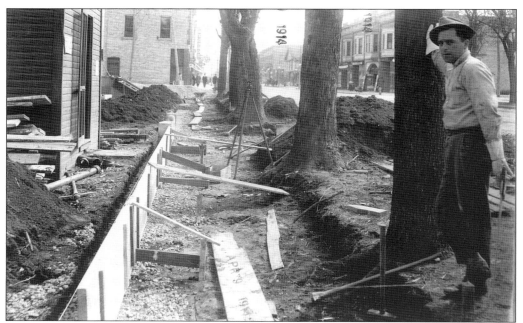

Dan Jackson, a well-known Rochelle plumber, takes a break in April 1914 during the construction of the new post office. Prior to this construction, the first floor of the Stocking building had been the location of the post office. Horses and a carriage wait far down the street between the trees. (Courtesy of Rob Whipple.)

John Hotaling was born March 3, 1824, in New York State. Trained as a printer, he traveled often to South America, once sailing around Cape Horn to California with 60 men. There, in 1849, he tried the gold fields. Two years later, he married his wife in Rochelle and ran the stagecoach line, then became postmaster. In 1861, he raised a Civil War cavalry, becoming a major in the end. (Courtesy of FTHM.)

POST MASTER
ROCHELLE

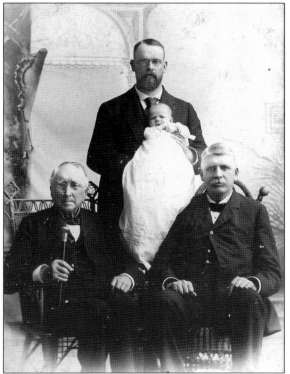

In this four-generational photograph, William Horace Holcomb Sr. sits with his cane and spectacles. Beside him is his son, William Horace Jr., mayor from 1879 to 1880. His son Will holds his baby daughter, Anne Faye. The first appointed mayor was Henry O. Rogers, taking office on November 4, 1872. The first election was held on April 15, 1873, and Delos A. Baxter was elected mayor along with three ward aldermen. (Courtesy of FTHM.)

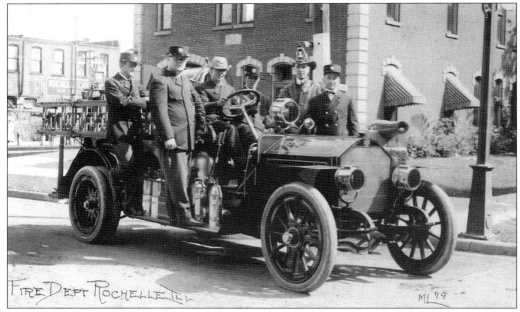

The six volunteer members of the Rochelle 1910 fire department gather on the fire engine beside city hall. David Garrison is the driver and one of two paid firemen. From left to right are Orrin Sherwood, Ben Berve, David Garrison, John Maxson, Charley Healy, and Fred Gardner. The sign in the left distance is for the Rochelle Candy Kitchen. (Courtesy of FTHM.)

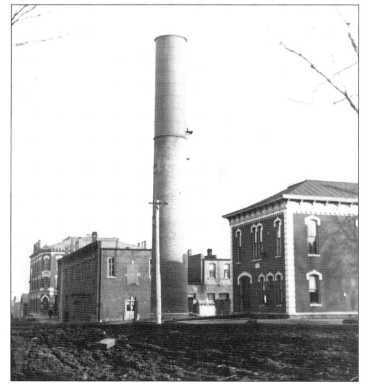

For $4,000, a 113-foot standpipe was built in 1890 next to the city hall. For 30 years, the pipe furnished water pressure for the city. It was a landmark seen for miles until its removal in 1920. The stone, 20-foot-diameter foundation was transformed into a flower bed until 1931. The streets are still dirt, but an electrical pole indicates electricity, which was begun in 1893. The Bain Opera House stands in the distance. (Courtesy of FTHM.)

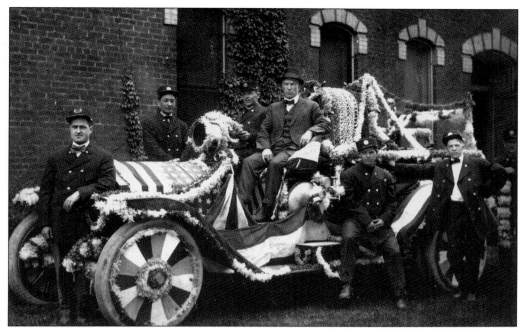

In the early 1900s, the fire engine is decorated for a Memorial Day parade, right down to the wheels. Fire Chief Herbert Bain is in the center, dressed in his suit. The other firemen are, from left to right, Walter Kelly, Joe Unger, Dave Garrison, Nick Binz, John Maxson, and Sam Hamaker (partially hidden). (Courtesy of FTHM.)

In the 1890s, this view was of Brice Street (Fourth Avenue) at Bartholomew Street (Seventh). This shows the top and the base of the standpipe and city hall on the right. On the left stand the stately elm trees where the library is now built. Farther down the street, the horse is tied at Bob Sipe's blacksmith shop. Beyond, the Parker Book Store could be found. (Courtesy of FTHM.)

Wilbur B. McHenry, the longest serving mayor, continued from 1901 until 1919. He was reelected in 1939 and then defeated in 1943. He served for just a few months shy of 23 years, according to the *Rochelle Sesquicentennial Souvenir Program*. The commission form of government began in 1911. The city changed to the council-manager style in 1994, with a 1,095–986 vote. (Courtesy of FTHM.)

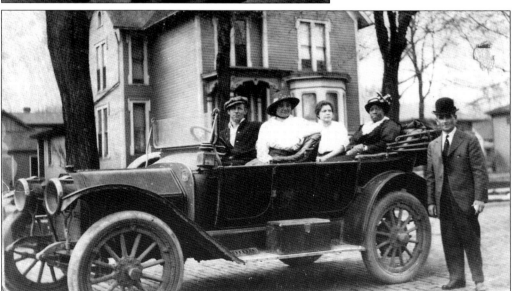

Rand Alexander drove Dixie Southworth and Mrs. Williams (back seat with maid) to the polls. McHenry, a future mayor, stands beside the car. On August 26, 1920, American women were granted the right to vote by the 19th Amendment. More than eight million women in the United States voted for the first time. New Jersey women could vote in 1776 because the word "people" was accidentally inserted; this was rescinded in 1807. (Courtesy of FTHM.)

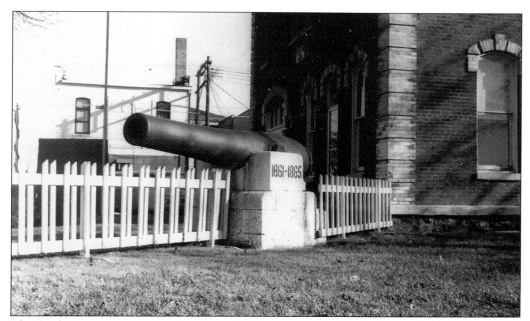

The Civil War veterans arranged and installed the cannon that sits in the yard of the old city hall. It has never been fired. James Brundage, whose home lay directly in the cannon's shooting path, is rumored to have asked the city fathers to fix the eight-inch diameter, Columbriad 9000 cannon so it could not be shot. The shells sitting at its base were 10-inch. (Courtesy of FTHM.)

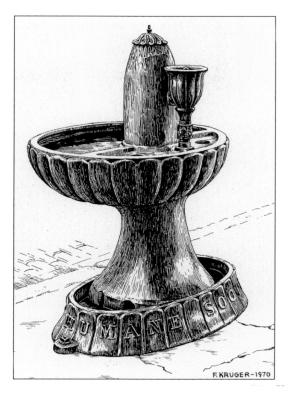

The cast-iron drinking fountain was a gift in 1915 from Laura Fessler and other citizens. The distinctive fountain, originally located on Fourth Avenue's sidewalk, offered liquid refreshment to people from the spigot, to horses and mules from a semi-circle trough, and to dogs, cats, and other short creatures from a lower basin. Today it stands outside the history museum at Fourth Avenue and Sixth Street. Franklin Kruger's drawing depicts it well. (Courtesy of Franklin Kruger.)

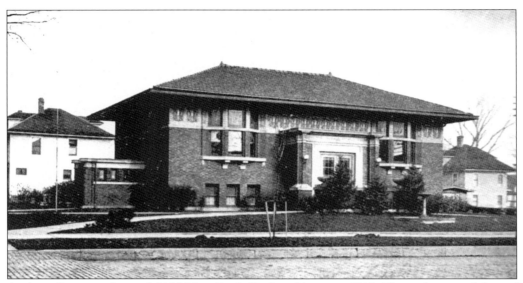

Andrew Carnegie donated $10,000 to Rochelle for a library in 1910. The architectural firm of Claude and Starck of Madison designed the building. Frank Lloyd Wright had been a member of Louis Claude's former architectural company. Thus Flagg Township Library contains the influence of Wright and is an example of the Prairie School–style construction. The library was placed on the National Register of Historic Places in 1973. (Courtesy of FTHM.)

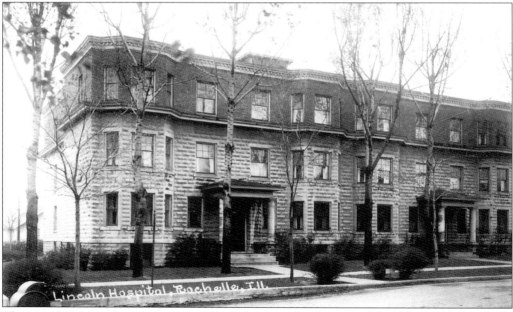

The Lincoln Hospital was opened in 1913 on the west side of town on Woolf Court. The Rochelle Community Hospital was built at 900 North Second Street on the east side in 1945. Its location is near the two nursing home facilities: Rochelle West and Rochelle East Health Care Centers. On May 3, 2004, a groundbreaking ceremony began the expansion program. In January 2006, the new surgical department was opened. (Courtesy of Sue and Denny Golden.)

This 1895 photograph is of Dr. Dodge, the second horse doctor in Rochelle. Before veterinarians were commonplace, horse doctors practiced with foul-smelling liniments. Art Nelson noted that most "horse doctors were of the quack variety." Dr. Dodge, however, had attended veterinarian school. His office was located at the Si May livery stable. He served the area many years and then moved to Polo. Dr. Pullin was the first horse doctor. (Courtesy of FTHM.)

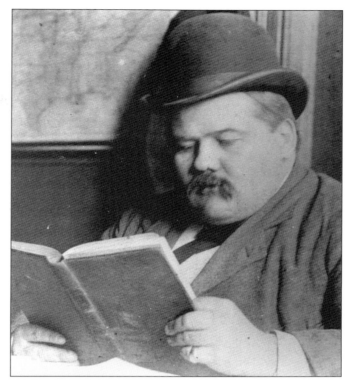

Dr. G. W. Gould was one of the early doctors to Lane. He had studied medicine before the Civil War and had been a surgeon during that war. He and his wife had raised three daughters. Josephine married Mr. Judson; Trudy married Mr. Franklyn; and Anna married Willard Graham, a banker. (Courtesy of FTHM.)

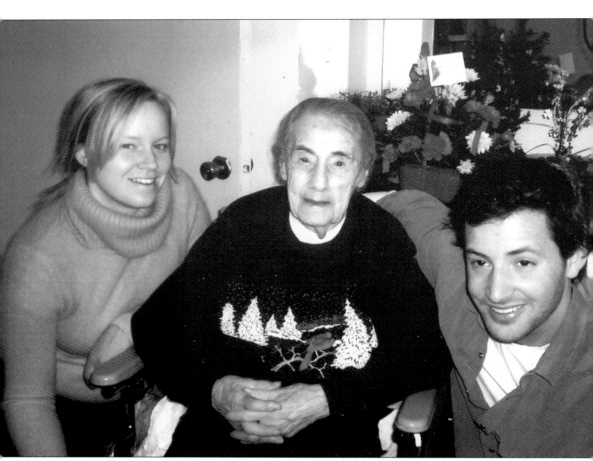

Marie Dunahoo, age 100, visits in her room at Rochelle East Health Care Center on Caron Road with her great granddaughter Keri Collamati and Keri's husband, Anthony, of Chicago. Rochelle East is one of two nursing homes and has approximately 40 residents. The city also has Rochelle West Health Care Center across from the hospital. Marie is the eldest of the 15 children of Frank and Mabel Strang from Lindenwood. She married Austin Dunahoo, and they lived in their home in Lindenwood for over 75 years. Their small house is the oldest in Lindenwood and had originally been the parsonage for the Immanuel Lutheran Church. Marie and Austin, who died in 1992, raised three daughters and one son, and they have nine grandchildren, six great grandchildren, and two great-great grandchildren. From Marie's original large family, she has six living siblings: one brother, Calvin, and five sisters, Ruth, Grace, Vera, Iris, and Margaret. (Courtesy of Leah Anderson.)

Five

THE COMMUNITY OF ROCHELLE

The early railroad provided a chapel car and freely transported it to cities where the car was sidetracked for a few weeks. In 1854, Thornton Beatty, a Presbyterian, conducted the first religious service in Lane from such a chapel car. Mrs. J. McConaughy organized the Sunday School for the chapel car on a side track near Patterson Lumber Company.

The Presbyterian Church began on September 1, 1854, with 10 members. They met in the log schoolhouse. The Reverend A. Miller was the temporary, first-year pastor. A church was built (1857–1858) for $3,000 on land donated by Colonel Brice, where today stands the municipal building.

An itinerate priest offered the first Catholic services in 1853. Father Kennedy traveled from Dixon regularly in 1856. He built the first church, though it was flattened during a storm. Patrick Kelly offered his residence until the church was finished. Father Duhig was the first resident priest in 1868. The first St. Patrick's Catholic Church was built in 1890; the rectory was built in 1900. The first baptism in 1869 was Mary Catherine Kellher. The first marriage was for John McDermott and Mary Lastrange in 1870.

The Baptist denomination arrived into Rochelle in 1868 by constructing a white frame church on Eighth Street and Fourth Avenue.

The Reverend A. C. Staats, Lindenwood pastor, held the first service at St. Paul Lutheran Church in February 1897 in the home of William Woodrick on Tenth Street.

"When you and I were young, Maggie," hummed John Butterfield, born and raised in a house on Avenue C. He wrote the music to the song's words by lyricist George Johnson.

Egbert Anson Van Alstyne, known in Rochelle as Bert, wrote popular sheet music for his era: "Pony Boy," "I'm Afraid to Go Home in the Dark," and "Good Night, Ladies."

Jurusha Mills purchased the Mortimer Hathaway Jr. residence at Sixth Street and Sixth Avenue. Mose and Jurusha Mills were the first people to leave Lane in an oxen-team wagon train for California in 1849. When Mose was killed by Native Americans, Jurusha and her daughter returned to Lane to live.

This photograph shows the old Presbyterian church around 1895. The congregation sold their building to the Rochelle Universalist organization, and a new church was built on Ninth Street in 1874 for $16,000. Its steeple was considered the highest point in Rochelle but unsafe, so it was removed. Dr. Gould's house sets to the right. In 1969, their present church was built on Calvin Road. (Courtesy of FTHM.)

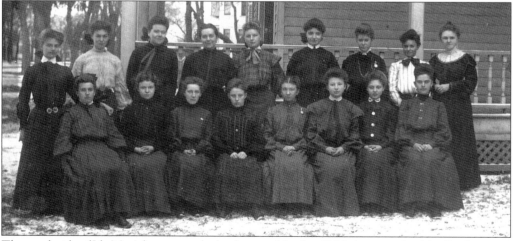

The south side of Ida May's home was the background for this 1906 photograph of the Presbyterian Women's Sunday School class. From left to right are (first row) Margaret McConaughy, Blanche Williams, Genevieve Allaben, Helen Bly, Fanny Louise Pierce, Jennie Lazier, Maud Marten, and Edith Knutson; (second row) Ruth Atwater, Edna Guthrie, Dora Ellsworth, Hilda Berve, Elsie Wedler, Bessie Sipe, Lena Hansen, Lucile Hamlin, and Ida May, teacher. (Courtesy of FTHM.)

Rev. Israel Brundage was one of the first Presbyterian pastors, serving in the 1870s. He was born in 1828 and died in 1890. The old timers wrote of him, "He was the kind of pastor who could swing a scythe in the grain field or shoot a rifle with the best of them." (Courtesy of the Flagg Township Historical Museum.)

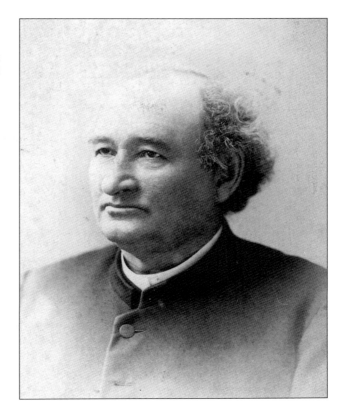

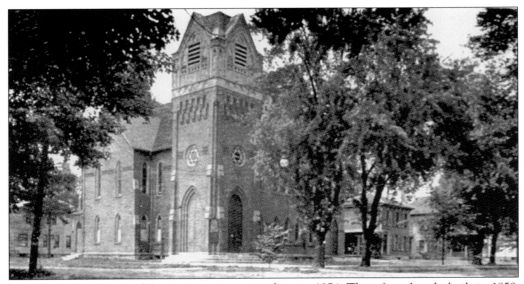

The Methodist Episcopal Society met in town cabins in 1854. Their first church, built in 1859, stood on the corner known as "Methodist Corner." The congregation worshipped in the basement during the construction and dedicated the building in 1862. That building was sold, moved, and later torn down. This church photograph had been a postcard. (Courtesy of FTHM.)

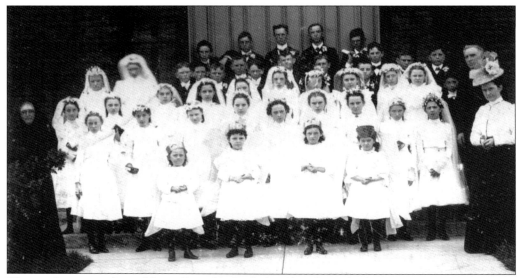

The confirmation class of Saint Patrick's Catholic Church in the late 1800s is remembered in this photograph. Rev. Thomas Finn was the priest. Sr. Mary Regina stands to the left in her dark habit, and Miss Dolly, a helper, stands in front of the Reverend Finn. The younger girls wore crowns, while others wore veils with flower headpieces. (Courtesy of FTHM.)

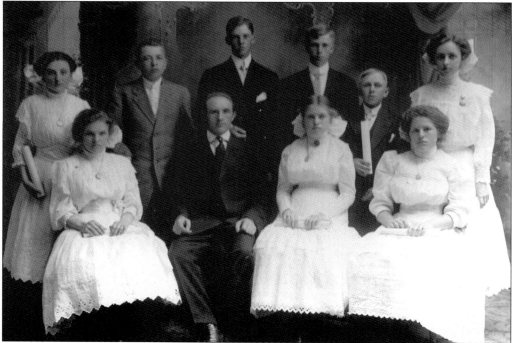

This is an early 1900s St. Paul Lutheran's confirmation class, though all are unidentified. St. Paul's Evangelical Lutheran Church and parsonage at Fifth Avenue and Tenth Street were built in 1900. Prior to December 7, 1941, church services were held in German and English. The present church and parsonage are located at 1415 Tenth Avenue, dedicated in 1960. The Lutheran Day School was dedicated in 1964. (Courtesy of FTHM.)

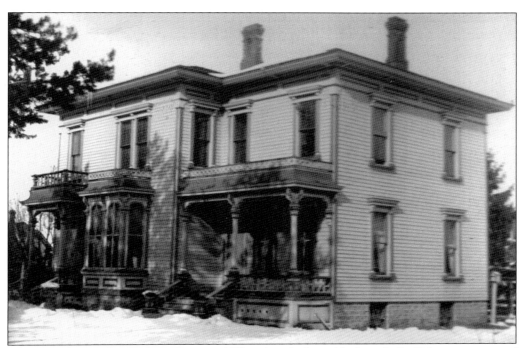

John T. Bird arrived in Hickory Grove in 1855 and worked as a blacksmith. Bird's house was one of the first built on the residential side near the original site of Willard Flagg's log cabin. This photograph was taken about 1875. Bird constructed a brick shop at Lincoln Highway and Fourth Avenue that was lost in an 1870 fire. Later he joined the bank of Lewis and Bird. (Courtesy of FTHM.)

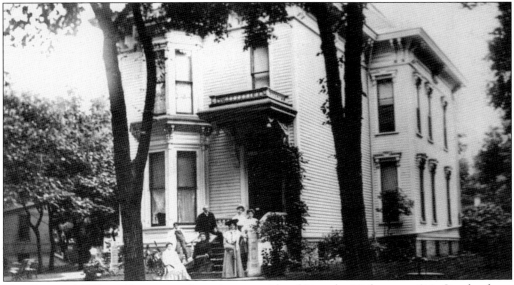

The Emanuel Hilb residence stood on the west side of Lincoln Highway at 614. On the front porch stand Mr. and Mrs. Hilb, their adopted daughter, Blanch Wolff, and their visitors that particular day. The house was remodeled into the Lucile Kelley apartments. His brother Adolph's home was considered haunted. A former owner identified the ghost from a photograph of Mrs. Adolph Hilb, so the story goes. (Courtesy of FTHM.)

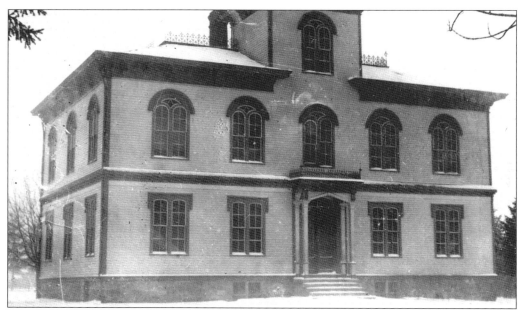

In 1875, for $10,000, Miles J. Braiden built this house between Avenue D and Avenue E. It burned the next year. Braiden came from Wyoming County, New York, in 1850. He started in the grain business and then built a stone elevator beside the CNW Railroad. His other businesses included farmer, builder, lumber, coal, icehouse, and stone quarry. He was known to give employment to the working class. (Courtesy of FTHM.)

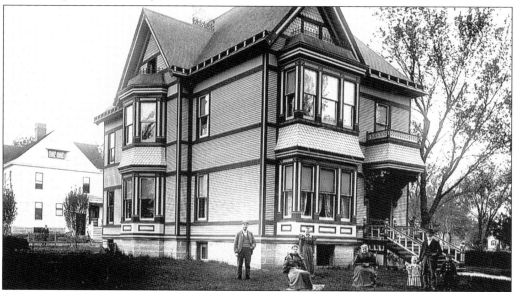

Four of eight Countrymen brothers—Harvey, Alvin, John E., and Norman—worked large surrounding farms. They married four Wagner sisters, Laura, Elizabeth, Rose, and Jenny. These eight individuals had transplanted from the same New York State county of Herkimer. This 1898 home belonged to Harvey and Laura. From left to right are Fred Craft, Ida Craft, their maid Amelia Oleson, Laura Countryman, John Craft, Harvey Countryman, and Harvey Phelps, a cousin. (Courtesy of Arlyn and Debbie Van Dyke.)

Alvin and Jenny Countryman built their residence at 603 North Eighth Street. After retiring from farming and moving to Rochelle, three brothers, with partner R. P. Benson, formed a stock company and built a cheese factory until in 1876 when they made it into a creamery. They produced up to 40,000 pounds of fine butter yearly to ship to New York City. (Courtesy of Peri and Greg Query.)

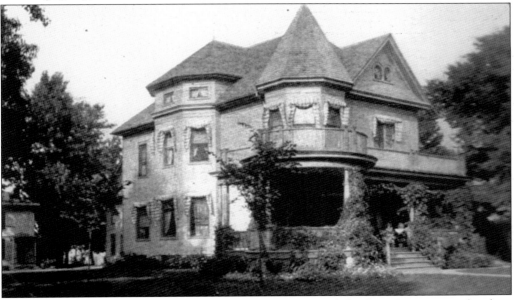

This is the home of John Alonso Countryman, a cousin of the four Countryman brothers who farmed around the Rochelle area in the late 1800s, coming from New York State. Upon retirement, John and the brothers built elegant Rochelle homes. John Alonso was in the cattle business near Lindenwood. (Courtesy of FTHM.)

This horse-and-buggy day home, named Greenhurst, was owned by J. O. McConaughy on North Seventh Street. McConaughy arrived in Lane in 1854 and purchased the Lane farm, where he created his Greenhurst on a 10-acre tract of land in the northwest portion. As a real estate dealer, he plotted three additions to the city and built private homes. (Courtesy of FTHM.)

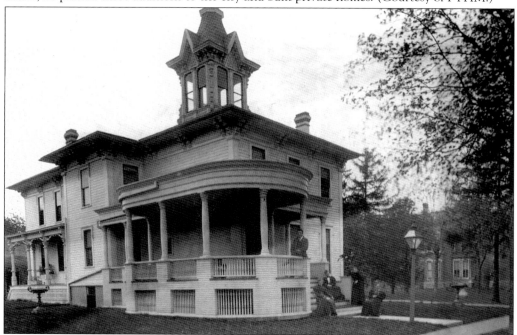

The Angus Bain home at 510 North Seventh Street was a duplicate of his wife Deborah's home in New York State. Her parents allowed Bain to marry their daughter and move her west, as long as he copied a house like theirs for her. Eventually the house was sold and made into apartments. (Courtesy of FTHM.)

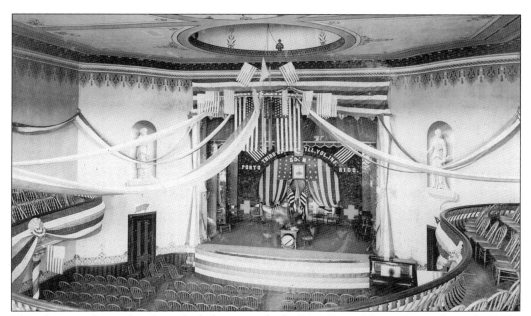

This photograph was shot from the balcony inside the Bain Opera House during the early 1900s. Men referred to the balcony as the "peanut gallery" in the old days. According to the banner, the opera house was decorated for a special event involving the Spanish-American War. Note the beautiful ceiling, which included a lighted dome. (Courtesy of FTHM.)

The Gothic residence of Mrs. S. M. Cass was built in 1891 on the southwest corner of Washington Street and Sixth Avenue, one block from the post office and two blocks from Rochelle's town center. The home's interior was divided into 12 rooms. The house was steam-heated and supplied with hot and cold soft water through storage tanks in the attic. (Courtesy of FTHM.)

The wood-constructed house of Dick Beers was one of the first built in the locality in 1854. Beers had purchased his 40 acres in section 36 in 1846. With a white beard, Dick Beers sits in the first row, at left center. His wife, Dolly, is the white haired woman in the next seat. They had four daughters. (Courtesy of FTHM.)

This aerial photograph of the Tilton homestead was taken in the 1940s. This is where the Tilton twins, Mark and Mabel, were born in the early 1900s. Note the fancy television antenna. The Tilton family eventually diverged into many other areas of businesses such as banking, construction, and the local newspaper. (Courtesy of Ted Tilton.)

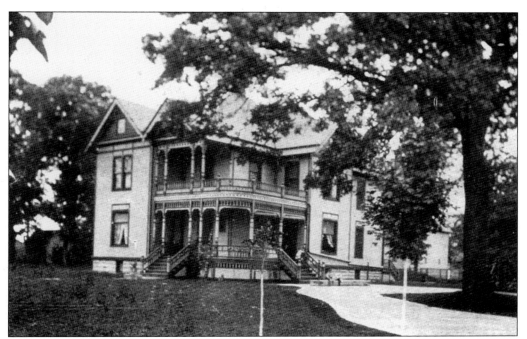

The large white oak to the right of J. William and Kathryn Southworth's farmhouse is an original one from when the first white settlers arrived in Hickory Grove in the late 1830s. The log schoolhouse was built on this site in the 1840s and used until 1854. The photograph was taken in 1907. (Courtesy of FTHM.)

These new, 1900 William Lux cottages stood on Fourteenth Street. Older people have said that lawns were not mowed then. They flattened grass everyday by walking on it or letting an animal, such as this cow, eat the lawn down. The first patent for a mechanical lawn mower was granted on August 31, 1830, to engineer Edwin Beard Budding from Stroud, Gloucestershire, England. However, they cut grass in France in the 1700s. (Courtesy of FTHM.)

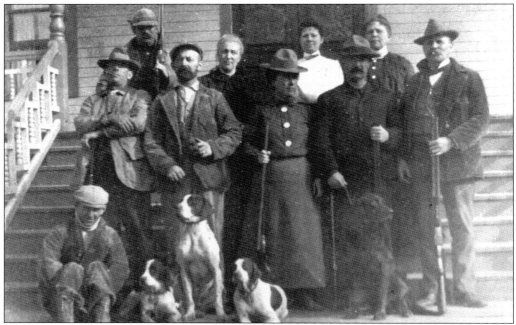

The 1902 photograph shows the local sports people ready for a quail-hunting trip to Sailor Springs, Illinois. The wives accompanied their husbands into the hunting fields and dressed according to that era's style. From left to right are (first row) Tom Southworth; (second row) Bob Sipe, Clarence Gardner, Mrs. Bain, William Bain, and Mr. Johns; (third row) William Southworth, Mrs. Gardner, Mrs. Tom Southworth, and Mrs. Johns. The dogs are unidentified. (Courtesy of FTHM.)

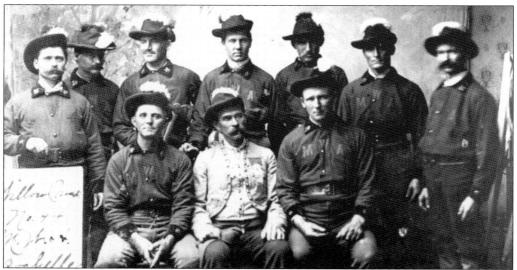

These men are the drill team of the Modern Woodmen of America, Willow Camp Lodge No. 44 of Rochelle. The photograph was taken August 16, 1900, before they showed their work. Seen here are, from left to right, (first row) Gene Horton, Louis Berve, and Bert Anderson; (second row) Charles Burright, George Onley, Lou Varner, Charles Lux, Rasmus Jepson, John Varner, and August Berg. (Courtesy of FTHM.)

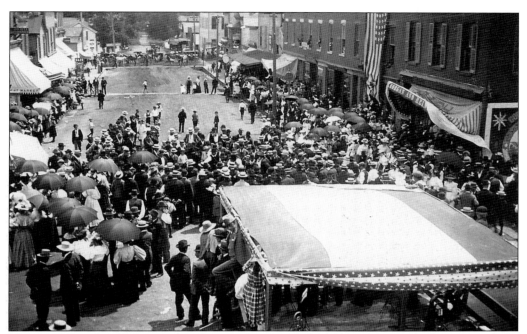

This 1895 Fourth of July crowd gathers at the west end of Cherry Street, looking toward the Washington Street bandstand, where the fireworks will be on display. Charley Taylor was in charge of the display for several years. The old corner brick building is on the right and housed the Morgan and Heintz General Store with the Ancient Order of United Workmen hall upstairs. (Courtesy of FTHM.)

Mr. and Mrs. Edward Crawford sit in the front seat of their Reo after qualifying for first place in the Fourth of July parade. In the back seat are, from left to right, Mrs. Ellie R. Smith (Mrs. Crawford's mother), Mrs. Millie Onley, and Mrs. Agnes Vaughn. The Reo automobile was made in the United States from 1904 to 1936. (Courtesy of FTHM.)

The Daughters of the American Revolution hold a social meeting in 1912 in the private park owned by Willard and Anna Graham on Eleventh Street. Their house was designed by architect Frank Lloyd Wright and built in 1910. The private park was named Western Park Addition. The two women seated at the table in the foreground are Mrs. A. W. Guest and Mrs. Burr Sheadle. (Courtesy of FTHM.)

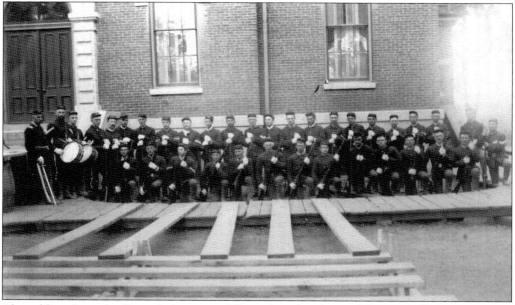

The soldiers from the Spanish-American War gathered in front of the city hall for Decoration Day. On April 20, 1898, Pres. William McKinley signed the Joint Resolution for war with Spain. Among the participants were well-known people as Pres. Grover Cleveland, Pres. Theodore Roosevelt, Adm. George Dewey, and author Mark Twain. (Courtesy of FTHM.)

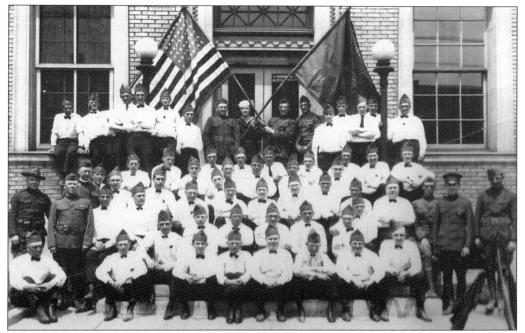

The American Legion of Rochelle was founded in 1919 with Fred E. Gardner at its commander. The national organization works on behalf of veterans, their survivors, and their children. Post No. 403 was recognized as a corporation under Illinois laws on April 23, 1929. The post's purpose is to serve the community, state, and nation. (Courtesy of FTHM.)

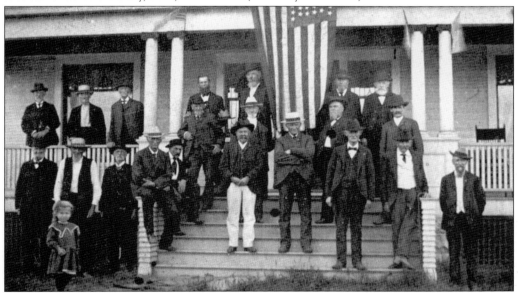

This is the Grand Army of the Republic No. 546, on July 14, 1903. The little girl is Helen Cobb. The rest are identified as W. Tibbles, Swen Larson, J. McConaughy, John Farnham, W. Mead, D. Talbot, J. Trenholm, George Turkington, R. King, George Harr, S. Houston, George Hochstrauser, Charles Parmley, Frank Barker, Horace Ensign, Morris Tracy, Al Ward, J. Thorp, B. Pulver, O. Randall, and Henry Henzie. (Courtesy of FTHM.)

Vernon Mead of Rochelle poses with Roy Butler of DeKalb and his dog, Cuba, who was mascot for Company M and traveled with the boys to Puerto Rico in 1898. Cuba was a popular company member and was often in their group photographs. After returning from Puerto Rico, Cuba was hit by a train in Rochelle. (Courtesy of FTHM.)

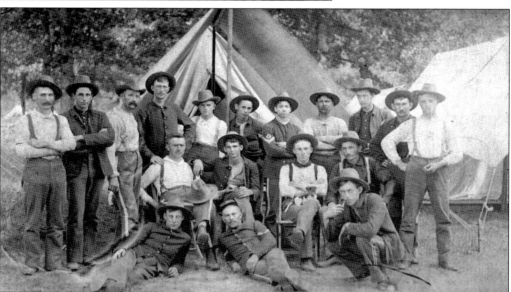

Company M had their photograph taken July 26, 1892, on their way to the Spanish-American War. From left to right are (first row) Bill Cargain, Em Swiney, and Lloyd C. Ingraham (who later directed and acted in Hollywood movies with John Wayne); (second row) John Thompson, W. Cadwell, Red O'Neil (with puppy), and Charley Hayes; (third row) Alex Morrison, ? Smith, August Caspar, Art Darling, ? Silby, B. Cadwell, W. Hackett, Jack Gaylord, Clarence Eyster, Henry Unger, and Frank Binz. (Courtesy of FTHM.)

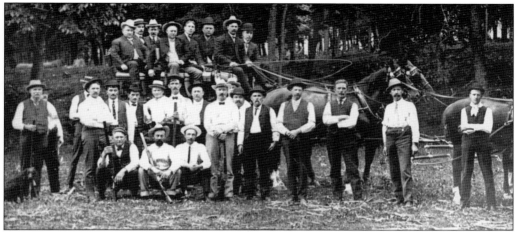

The Sportsmen's Club included many Rochelle's businessmen. Somewhere in the photograph are Delos Baxter, George Unger, Charles Millotte, Henry Faust, M. Hathaway, Aaron Guest, E. Vaile, John Riley, A. Elmer, Walter Hamlin, and Michael Hayes. On their hunt in their tally-ho wagon, the men took Chicago businessmen, who brought in the Vassar-Swiss Company, which eventually became Caron Spinning Company. Tally-ho wagons were pulled by four horses and contained rows of seats. (Courtesy of FTHM.)

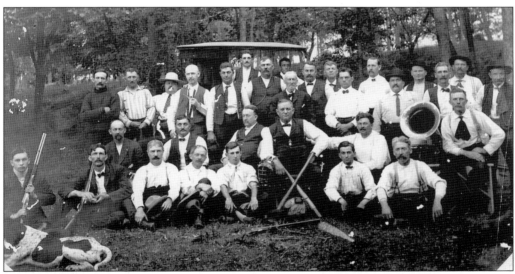

The 1895 Rochelle Gun Club consisted of, from left to right, (first row) Dan Hooley, Jim Nealis, William Bain, Dr. Busnell, Tom Southworth, Clarence Tilton, and Dave Kelley; (second row) Clarence Gardner, Charles Millotte, Dr. Elmer, George Unger, George Stocking, and Jim Riley; (third row) George Bird, William Southworth, Francis Dresser, Arron Guest, unidentified, Bruce McHenry, George Brown, Howard Morris, Dr. Robbins, George O'Brien, Wilbur McHenry, George Dicus, Henry Faust, John Flynn, Alex Morrison, Leonard Caspers, unidentified, and John Tripp. (Courtesy of FTHM.)

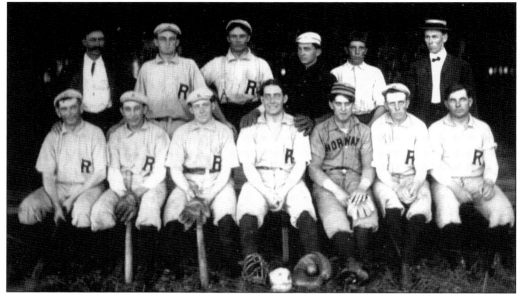

The 1904 Rochelle baseball team played at Klondike Park land originally owned by the pioneer Randall family. From left to right are (first row) Mr. Richardson, Joe Unger (pitcher), Frank Felvey, Bill Felvey (catcher), Frank Wiley, John Healy, and Ross Harker; (second row) Jim Southard (coach), Charles Unger, Henry Harms, Fred Gardner, Win Healy, and Frank Reynolds (umpire). Southard, a former Three I League pitcher, was one of first pitchers to throw a curve ball. (Courtesy of FTHM.)

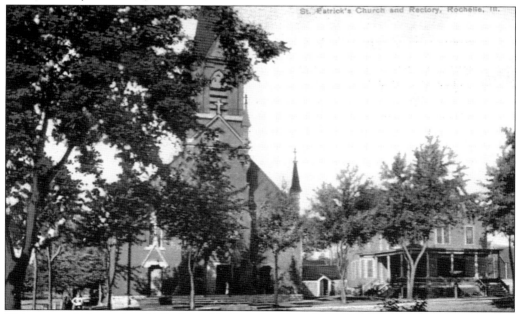

This postcard shows the old St. Patrick's Catholic Church, built in 1890, and the rectory built in 1900. The Catholics also built St. Patrick's School in 1929 with Fr. Thomas O'Brien as priest and headmaster. Sister DeChantal was principal. The present church is located on Kelley Drive. (Courtesy of FTHM.)

Six

THE HEART OF THE CITY

The heart of Rochelle throbs in its citizens. From early settlers such as Josiah (Si) May to any kindergartner at Phillip W. May School. Every one is special and passes the friendly Rochelle spirit on to visitors or those who choose to make Rochelle their new home.

Some have made their names known such as Lloyd Ingraham, born November 30, 1874, in Rochelle and died in Woodland Hills, California, on April 4, 1956. He had traveled to Hollywood in 1915. There he met his wife, Lois, who also acted in westerns. During his decades of work in filmography, he was an actor, director, writer, unit director, assistant director, and archiver of footage. He was involved in nearly 400 films. His grandfather was David Navarro Sr.

Phil W. May Sr. platted land for housing development. Phil May Jr. developed 136 acres of land into asparagus fields during the 1950s. Beginning with five stores and a bank, he built May Mart in 1956, which is known now as Rochelle Commons.

Frank Krahenbuhl was born in the United States after his family emigrated to Rochelle from Switzerland in 1893. From his apprenticeship at Sherlock Garage, Krahenbuhl decided to open his own business in 1923, the White Front Auto Laundry on Cherry Avenue. In 1940, he moved the business to Fourth Avenue and renamed it Krahenbuhl Garage. His sons, Bub and Dick, joined the business and expanded it to include a new building at Flagg Road and Highway 251 and the Chrysler Plymouth franchise from the Bain family in 1971. Bub and Dick drove high school buses for years. Bub's son Roger and son-in-law Ed Van Vickle joined the business. After Bub and Dick retired, Ed's son Brian continued the business into the fourth generation.

So many more could be written about, including Vincent and Mary Carney, Harry Beebe, Elzie Cooper, William Hackett, Arthur Guest, Harold and Lew Moore, Walter Sawicki, and more. These and the unidentified others who call Rochelle home have created the hometown atmosphere of the city.

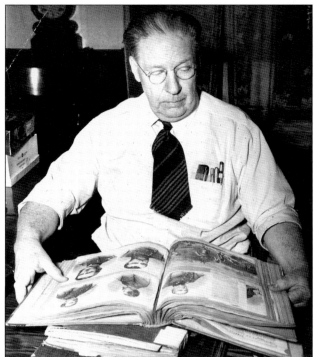

Art Nelson glances through his scrapbooks of history that he was known for keeping. He contracted polio as a teenager and walked with crutches for years until he used a wheelchair. He ran a livery business, set type for the *Rochelle Independent*, and worked as a timekeeper at Whitcomb Locomotive Works and the Lazier Garage office. Besides his avocation as a historian, he did woodworking and crochet. (Courtesy of FTHM.)

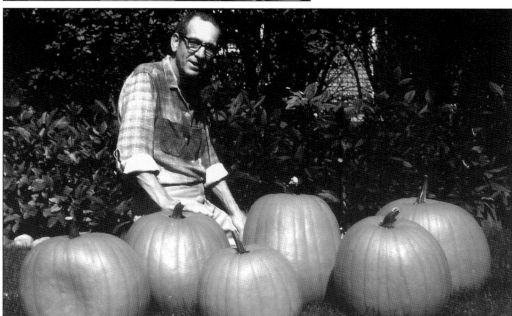

Franklin Kruger, age 84, is a retired high school art teacher living in Rockford. Under his direction as first president for the Flagg Township Historical Museum, volunteers began the reconstruction and restoration of the old city hall into a museum in 1971. The 1884 building is on the National Register of Historic Places. He accompanies his pumpkin crop in this 1968 photograph. (Courtesy of Franklin Kruger.)

90

Marion Garmory was born January 6, 1872, in Rochelle and died at 87 in Rockford. She had been a Rochelle country schoolteacher to Albert Nelson, Art Nelson's father. She was one of the first women to be admitted to the Illinois bar, and she practiced in Rockford. She never married. (Courtesy of Flagg Township Historical Society.)

John W. Royce was born March 16, 1847, and served in the Civil War. Afterwards he made his home in Idaho. His parents, Charles and Margaret (Rathburn) Royce, owned the Friday place on South Main Street. When they resided in Lafayette Township, his father had attended the trial and execution of the Driscoll gang. Among their crimes was the burning of the new Ogle County courthouse in the early 1840s. (Courtesy of FTHM.)

Brothers Nelson and Clifford Hayes lived on the farm of their father, Hiram Hayes, one mile east of Kings. They both played in the Rochelle Band in 1890. Nelson, left, was engaged in the milk business in Rochelle around 1912. Clifford operated the family farm. (Courtesy of Flagg Township Historical Society.)

Joan Marie Allen (front right) and her sister Lynn (in polka-dot dress) attend a birthday party. Joan had one chicken pox scab left below her nose. Joan and her two siblings grew up in Rochelle. She won a Tony for best actress and three Oscar nominations: two for best supporting actress and one for best actress. She and her daughter, Sadie, live in New York City. (Courtesy of Dot Allen.)

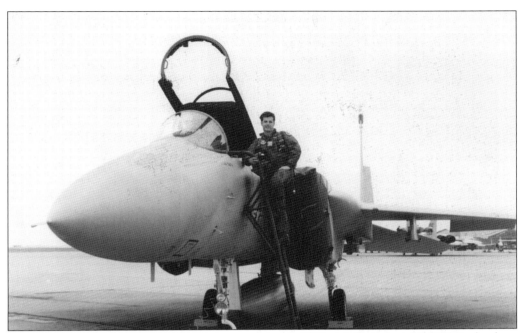

Maj. Thomas F. Koritz, a Rochelle native, was born in 1953 and died when his F-15 Eagle plane was shot down on January 17, 1991, during the Persian Gulf War. The Rochelle airfield, a San Antonio garden, and a North Carolina clinic have been named in memory of him. He was the son of Dr. Thomas L. and Mary Koritz of Rochelle. (Courtesy of Dr. Tom and Mary Koritz.)

Dr. Thomas Koritz, medical general practitioner for 35 years in Rochelle, also taught another 15 years at Mt. Morris Clinic for the Rockford School of Medicine, totaling 50 years in medicine after his retirement. He was given an award as one of the 10 best men in the United States by the United States Chamber of Commerce. Here he sits with his six grandsons (from left to right), Tim, Scott, Scott, Brett, Jon, and Andrew. (Courtesy of Dr. Tom and Mary Koritz.)

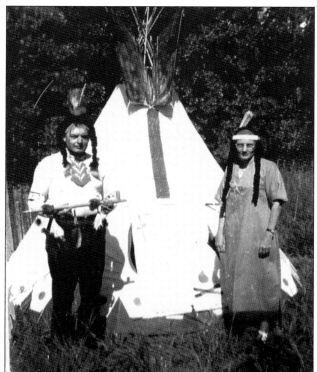

Floyd and Betty Barnes stand in front of the tepee they constructed. Floyd holds his handmade peace pipe. They presented many programs to schools and organizations about Native American lore. They were also ham radio operators, Rochelle historians, and family genealogists. Betty worked with Estelle Von Zellen to plan and write a walking tour for Rochelle children. (Courtesy of Betty Barnes.)

Earl Chapin May and Stella Burke were married November 10, 1909. This photograph is from their honeymoon. May grew up in Rochelle and played cornet. Later when their writing careers flourished, they lived in both New York City and Rochelle. Their only children were volumes of books, such as *A Century of Silver*, and multitudes of magazine articles such as "The Silver Cornet Band" in the July 5, 1924, *Saturday Evening Post*. (Courtesy of FTHM.)

Libbie Burbank was a farmer's wife who lost both her arms in a farming accident. Even so, her artistry came forth, and she painted beautiful pictures by using the brush with her mouth. She also wrote poetry and sang in quartets. (Courtesy of FTHM.)

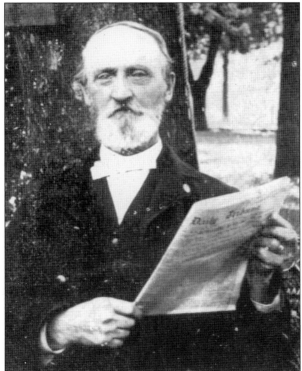

George E. Turkington was born June 4, 1827, in Danbury, Vermont, and moved to Lane in 1853 because he was in the railroad business. He was a town clerk and secretary of the agriculture society. In the Civil War, he was captain of Company H of the 140th Illinois infantry. He and his wife had two children, George Jr. and Anna. His Civil War letters are in the Rockford Museum. (Courtesy of FTHM.)

Leonard D. Carmichael holds the clapper of the bell in his small hand as he sits in his button shoes. Who would have guessed then that he would be this year's grand marshall of Rochelle's Heritage Festival parade? He is the head of Maplehurst farms near Lindenwood. (Courtesy of Leonard D. Carmichael.)

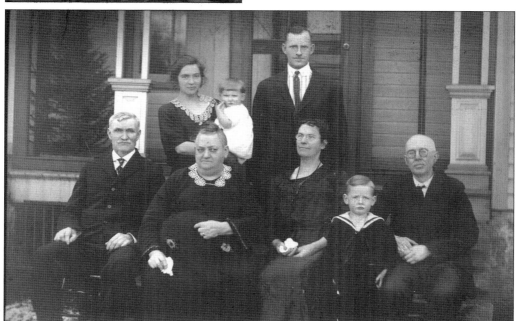

This generational photograph of the Carmichael family includes, from left to right, (first row) James, his wife Alma, Alice and Jim Sommers (Leonard Sr.'s in-laws), with Leonard Jr. in his sailor suit between them; (second row) Mabel and Leonard Sr. with their daughter Eleanor. (Courtesy of Leonard D. Carmichael.)

Mrs. A. Hustler, right, poses with her brother Mr. Holgate and his daughter Doriene. The Hustler family lived on South Third Street. Mr. Hustler was an executive of the Caron Spinning Company. His wife was only four feet tall and active in Rochelle society. Her brother, also a midget, lived in a community for midgets in Chicago. Doriene, an average-sized person, lived with the Hustler family. (Courtesy of FTHM.)

This is a photograph on a Christmas card sent by Vincent and Mary Carney of their children. Every year the Carneys' Christmas card included a photograph of the children on the front. Carney was in a long-time business, Carney and Longenecker. Vincent and Mary were active in supporting the arts in Rochelle. The Vincent Carney Theater is named in recognition of them. (Courtesy of the Flagg Township Historical Museum.)

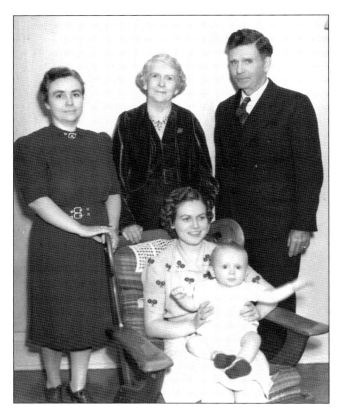

The five-generation photograph is of Rebecca Boyle Tilton (center), her son Dan, his daughter Florence Tilton (left), Florence's daughter Della Mae Lazier (seated), and Della's son Bruce on her lap. Orin Tilton had a twin, Warren. Orin fought in the Civil War in the 140th Regiment, Illinois Volunteer Infantry. He married Rebecca after the war, on August 24, 1870. (Courtesy of Ted Tilton.)

Cole and Dan Tilton are discussing the pros and cons of using or not using balloon tires. In the end, the two decided against balloon tires. They are at the old homestead. Their small, two-seater car perhaps contained a rumble seat. (Courtesy of Ted Tilton.)

The Tilton twins, Mark and Mabel, are dressed identically in white tights and spats. They were born to Spencer and Amy Tilton on the family country homestead in 1913. Mabel weighed a little over two pounds and was not expected to live, but her mother swaddled her and put her in a shoebox, and today she lives in California at a lively 92. Mark died in July 2006. (Courtesy of Ted Tilton.)

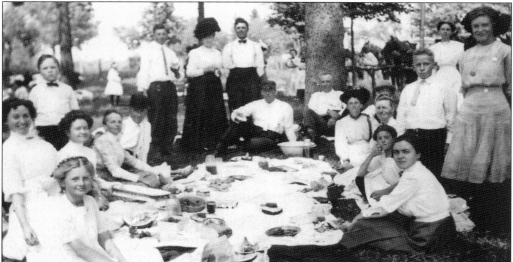

In the early 1900s, picnics were a fashionable form of entertainment. Here is a Tilton family picnic at Franklin Grove in 1912. Identified here are Doris Tilton, Hattie Tilton O'Neil, Mabel (Mrs. Dan) Tilton, Emmett Tilton, Lura Tilton Dugdale, James O'Neil, Lester O'Neil, Rebecca (Boyle, Mrs. O. B.) Tilton, Dan Tilton, Art Dugdale, O. B. Tilton, Dillon Tilton (hidden), Mary (Boyl, Mrs. Dillon) Tilton, Della Cole Tilton, Carl Dugdale, Ethel Tilton, Zelda Tilton, Maude Tilton, and Florence Tilton. (Courtesy of Ted Tilton.)

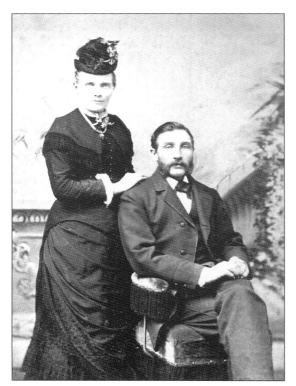

Mr. and Mrs. Charles Skepsted pose for their formal portrait around the 1870s. His expertise lay in stone masonry, lathering, and plastering while in Lane from 1869 until the late 1880s. He had worked on most of the houses built in the town and its vicinity during that period. (Courtesy of FTHM.)

Irvin Waukeshaw Charnock, seen here in the early 1900s, ran Charnock's Motel with his wife Dorothy. Irvin's brother was Harry Charnock, who built Harry's Sandwich Shop and Dairy Queen and also ran the Mobil gas station on Lincoln Highway. Irvin's middle name was the name of his mother's midwife. Harry Beebe, a pioneer hardware dealer, founded Beebe's Cabins in 1927, which evolved into Charnock's Motel. Dorothy was Harry Beebe's daughter. (Courtesy of FTHM.)

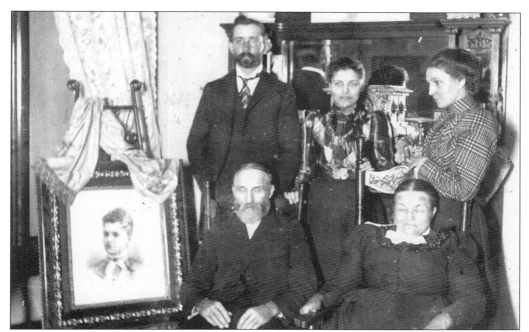

Alvin and Jenny Countryman sit in the parlor of their grand residence on North Eighth Street with their son-in-law, Henry Heckert; his wife, Emma (their daughter); and daughter, Minnie, at the unveiling of her formal portrait. Minnie died shortly after. They had also had a son who had died before them. (Courtesy of Greg and Peri Query.)

This delightful photograph by Colditz Photographers, an old Rochelle business, is of the Turkington men, young and old, though unidentified. The poses seen in the photograph are typical of the late 1800s era. Often they used stock backdrops, and every so often, identical backdrops would appear in people's family photograph collections. (Courtesy of FTHM.)

John Craft stands on the old porch of his home for his snapshot. His mother gently adjusts his head as she stoops to check his face. Perhaps young John did not enjoy having his picture taken. John was born in 1895 and became a University of Illinois college graduate, unusual in that era. (Courtesy of Arlyn and Debby Van Dyke.)

Ida Countryman Craft's wedding gown and shoes are displayed in a Rochelle church for a style show. She was a tiny-figured woman as one can see from the photograph of her dress. It was created from an unusual fabric with twill-like lines, yet shiny like satin. Its frontal decorations were triple-layered medallions of glass beads with a tiny pearl upon another pearl. (Courtesy of Arlyn and Debby Van Dyke.)

Ida Countryman Craft wears her wedding gown for her formal portrait. She and Fred Craft were married on December 2, 1891, in the front parlor of the home of her parents, Harvey and Laura Countryman. Fred and Ida died within one month of each other in April and May of 1914. (Courtesy of Arlyn and Debby Van Dyke.)

Fred Craft, the groom, sits for his formal, individual wedding portrait. He was John Craft's father and Ida Countryman's husband. He worked as manager and bookkeeper for the Braiden Lumber Company. John was their only child. Harvey and Laura Countryman—Ida's parents—had four children, of which two had died before them. (Courtesy of Arlyn and Debby Van Dyke.)

Ida and Fred Craft (middle and right) in their later years stand on a snowy day with Orva Craft (left), their daughter-in-law. More than likely the Craft's son, John, took the photograph. John was an investor and had served at Camp Grant in M Company, 342nd infantry, 86th division until 1918. He finished with the rank of corporal. (Courtesy of Arlyn and Debby Van Dyke.)

Seen here is Grandma Becky, as she was known to her grandchildren. Alice Rebecca Boyle was born July 8, 1854, in Utica, Ohio. She married Orin B. Tilton in 1870, and they lived on the Tilton homestead. They had three children, Daniel, born April 15, 1873; Eva, born August 25, 1875; and Leo, born November 20, 1881. (Courtesy of Ted Tilton.)

Seven

THE EDUCATION IN THE CITY

The first Hickory Grove school was held in a log cabin near Sheldon Bartholomew's cabin east of Shabbona Trail. Miranda Weeks was employed as its first teacher. She later married Constant Reynolds, another early settler.

For the second school, a building was specifically constructed and used until 1854.

A third was built in the 400 block on the west side of Sixth Street. This building eventually was turned into a gristmill.

Samuel Hanson became Central School's janitor in 1893. Many students passed through the school while Sam worked there, and their children and grandchildren. He was called "cheerful and patient." He never had his own family beyond the Central School students.

The graduating class of 1901 included only Frank "Boliver" Healy. He chose the correct year to be an only graduate. Most of the early graduating classes averaged a dozen students. From early alumni records, Art Nelson wrote that their later addresses covered most of the United States, including Alaska, and their occupations varied.

In 1908, the senior class of 10 boys and 8 girls published the first *Tatler*. Its staff included George Simons, business manager and treasurer; Arthur T. Guest, assistant business manager; Arthur Tigan, editor; Bernard V. Baker, assistant editor; Glen McClymonds, art editor; and Claude Clinite, photographer.

In this same year, C. E. Joiner was serving his fifth year as superintendent. The 1908 Board of Education included Fred Craft, president; Arthur Guest, secretary; Mrs. Wells Atwater; Mrs. Mortimer Hathaway; John Riley; DeLos Baxter; and Dr. George Bushnell.

The first *Tatler* had 50 advertisers, including Carney's Clothes Shop, Hackett Jewelry, Rochelle National Bank, and Rochelle Gas Company.

Other businessmen who backed the class's new endeavor were M. J. Braiden, J. Brewen, C. Reynolds, George Unger, B. Baxter, Mr. DeCoursey, W. Furlong, G. Hamlin, A. Hizer, R. McHenry, and Mr. Hilb.

One businessman's advertisement read, "Sullivan's Livery and Cab Line. Stylish rigs and fine horses for all occasions. Cab: 25 cents to all parts of the city."

Nellie Reynolds was the teacher of the one-room Corn Hill School north of Rochelle in 1895. The schoolhouse was later struck by lightning and burned. From left to right are (first row) Fred Cook, Edna Knight, and Pearl Ferguson; (second row) George Knight, Nellie Reynolds, and Jay Knight. The school bell rests on the teacher's desk, which is on a platform. The clock looks modern. (Courtesy of the Flagg Township Historical Museum.)

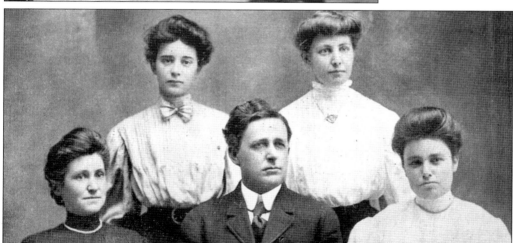

In the 1907–1908 Rochelle high school year, these were the teachers of the students: (first row) Mary McArdle, C. E. Joiner, who later became superintendent, and Mary Hunter; (second row) Inez Wilson and Clara Darst. The fashion statement for hair in those early 1900 days was in the upsweep, even for men. (Courtesy of FTHM.)

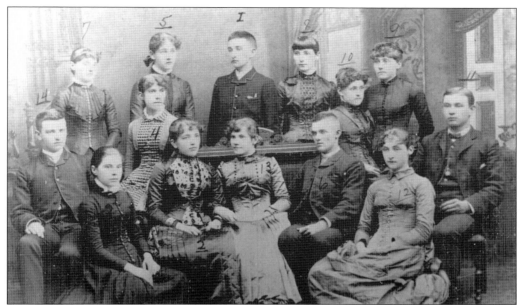

The Rochelle High School graduating class of 1885 included Frank Hathaway (1), Anna Farrington (2), Nettie Stringfellow (3), Nellie Francis (4), Maud Pierce (5), Ed Putman (6), Kate Hooley (7), Marie Guest (8), Ella Dunkleberg (9), Minnie Elmer (10), August Unger (11), Mary Warren (12), Rilla Sheadle (13), and Billy Boyle (14). Mr. Greenman was school principal. (Courtesy of FTHM.)

The late 1880s high school graduating class photograph contains prominent persons in Rochelle's future. Seen here, from left to right, are (first row) Earl Chapin May, Fern Scheaf, and Henry Shippy; (second row) Florence Coon (Mrs. Al Peterson), Blanche Howard, Bruce Brundage, Florence Parker, Floyd Countryman, Alice Scheaf, and Andy Elmer; (third row) Alice Countryman (Mrs. Art Lazier), Wallace Talbott, Alta Austin, Willard Graham, and Anna Gould. (Courtesy of FTHM.)

In the 1950s, the Rochelle Township High School marching band enters the cemetery on Memorial Day with the color guard holding the furling United States flag while an unidentified man salutes. People looked forward to seeing the marching band because of its expertise in line formation while playing precise, modern, spunky tunes. (Courtesy of Rob Whipple.)

The main entrance of the former Rochelle Township High School, built in 1921 and now razed, contained a trilogy of doors. Local pharmacist Bill Hayes was part of the basketball team to play in the new C. A. Hills gymnasium. In the late 1930s, Rochelle hosted Dixon High School, whose team included the late Pres. Ronald Reagan. Rochelle won that game. (Courtesy of Rochelle Township High School.)

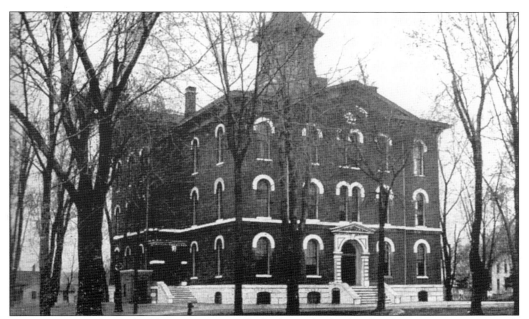

The three-story brick building was originally built as the high school in 1938 at 444 North Eighth Street. As housing needs arose, this building was renovated into Central School. Today the new Central School building houses 350 students with Neil Swanson as retiring principal. Jean Kisner will be the new 2006–2007 principal for the Central Cougars. Todd Prusator is superintendent of the school district. (Courtesy of FTHM.)

The present Rochelle Township High School was constructed in 2004 at the new site, 1401 Flagg Road. The building can accommodate 1,500 students. Its interior is painted in the school's colors of purple and white. The school's mission is "committed to excellence in preparing all students to be lifelong learners by developing and fostering academic, personal, and social growth." (Courtesy of Rochelle Township High School.)

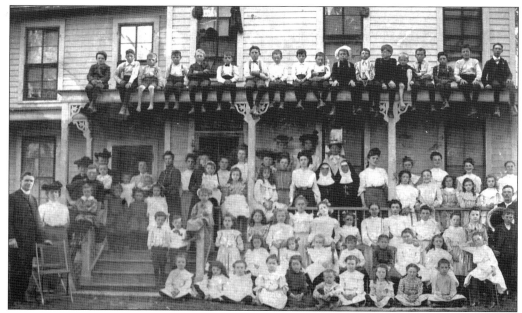

This St. Patrick's School picnic was held at the Reilly farm south of town in the early 1900s. Though none are identified, the photograph tells of the large crowd for the picnic and the fun the children must have had climbing out the upstairs' windows to line up on the porch roof for their photograph. A few are barefoot. (Courtesy of FTHM.)

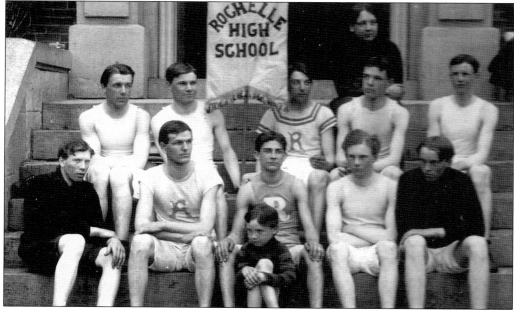

This early 1900s Rochelle High School track team poses for its photograph. They are, from left to right, (first row) George Maxson, Charles Hakes, Fred Way, Tom Schoonoven, and Gertis Elmer; (second row) DeWitt Vaile, Carl Dodge, Henry Slaughter, Joe McConaughy, and Herbert Brundage. At the top is Frank Healy, manager. Their mascot in front is Charles Allen. (Courtesy of FTHM.)

St. Patrick's School was built in 1929 while Fr. Thomas O'Brien was pastor. However, the parish opened its first school in September 1908 when Fr. David Conway was pastor. The sisters who taught were from St. Francis of the Immaculate Conception in Clinton, Iowa. The first school was held in a house. (Courtesy of Rob Whipple.)

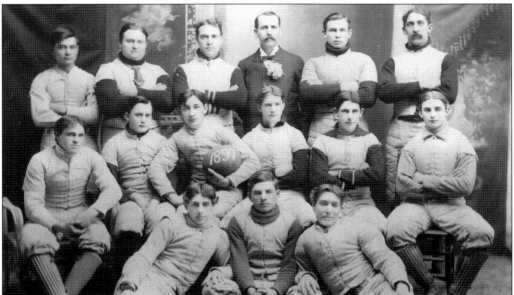

The 1897 Rochelle senior football team was comprised of business and professional men. From left to right are (first row) Charlie Berry, Ross Harter, and Bob England; (second row) Milo Patterson, Art Keene, Joe Unger, John Kahler, William Kendall, and Robert Stevens; (third row) Ed Schmerhorn, Dr. File, Rev. Crouse, George Dicus, Theodore Schade, and William Tindall. (Courtesy of FTHM.)

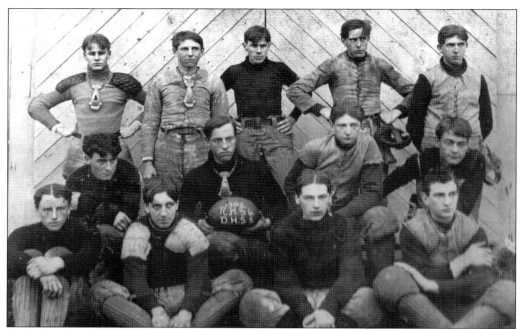

The 1902 Rochelle High School football team was the first, according to photograph's notes, to defeat Dixon 6-5. Included are, from left to right (first row) Jay Knight, Charles Healy, Art Evans, and Elwood Carmichael; (second row) Hime Winders, George Knight (captain), Earl Baker, and Charles Kramer; (third row) Jay Countryman, Curt Lazier, John B. Hayes (manager), Jack Healy, and Henry Wilcox. (Courtesy of FTHM.)

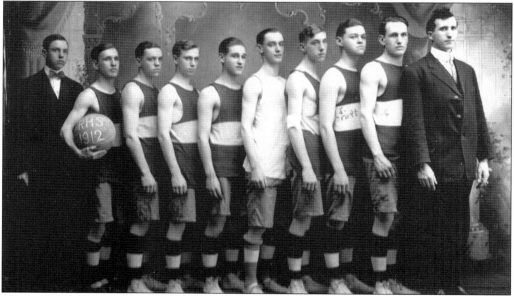

The 1912 Rochelle High School basketball team was comprised of, from left to right, R. Sipe, manager; C. Oleson, captain and forward; R. Cratty, guard and forward; J. Weeks, guard; M. Hathaway, guard; J. McNally, center; R. Sherer, forward; John Craft, center; J. Carpenter, center; and R. T. Johnston, coach. (Courtesy of FTHM.)

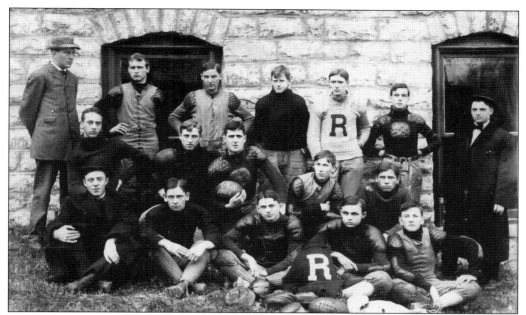

The 1906 Rochelle High School football team was comprised of, from left to right, (first row) unidentified, Leon Ward, Art Tigan, Art Guest, and Paul Rosenberg; (second row) Bernard Baker, Rea Dusher, Walter Kelley, Otto Weeks, and Irwin Orput; (third row) unidentified, Fred Larson, Gene Tigan, Leonard Carmichael, Glen McClymonds, Jeff Furlong, and unidentified. (Courtesy of FTHM.)

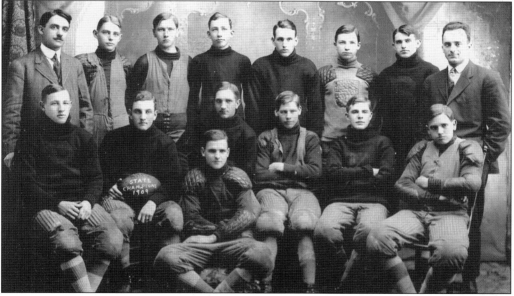

Rochelle High School again had a championship football team in 1909. Seen here are, from left to right, (first row) Lazier, Rosenberg, Healy, Harter, Barker, Titus, and Stevens; (second row) superintendent Mahoney, Phelps, Williams, Braiden, Carpenter, Maley, Kahler, and Gardner. This particular formal backdrop can be seen in other school photographs. (Courtesy of FTHM.)

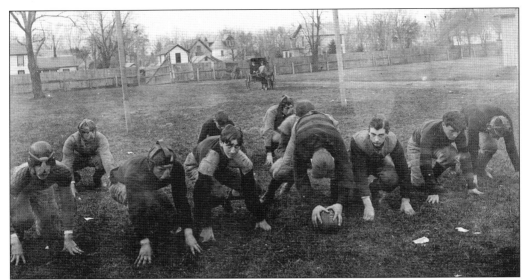

Walter Hamlin drove Professor Philbrook in his horse and buggy to watch the 1902 football team scrimmage on the old fairgrounds. The team included Jay Countryman, Curt Lazier, John B. Hayes, Jack Healey, Henry Wilcox, Charles Kramer, Earl Baker, George Knight, Hime Winders, Jay Knight, Charles Healey, Art Evans, and Ellwood Carmichael, though no team member is identified. The Vassar Swiss Underwear Factory was built on the site, later becoming Caron Spinning Mills. (Courtesy of FTHM.)

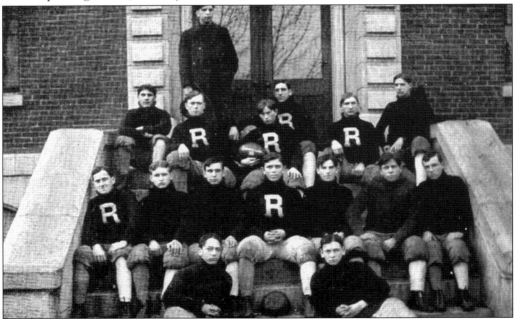

The championship high school football team of Rochelle in 1905 included, from left to right, (first row) Baker and Ward; (second row) Kelley, Larson, Furlong, Kittleson, Atwater, Orput, and Dee; (third row) McCann, Berve, captain Weeks, C. Healy, Lurquin, and McClymonds; (fourth row) Frank Healy, manager. The background for the photograph was the old high school. (Courtesy of FTHM.)

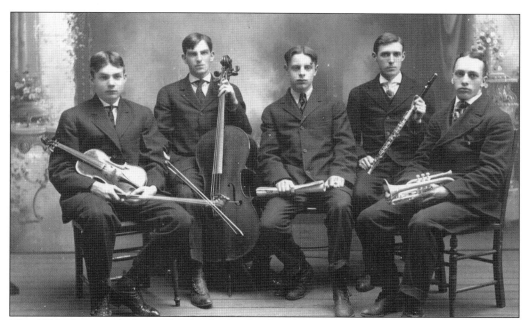

The 1905 photograph shows the first high school orchestra. Some men wore button shoes. The violinist wore lace ones. Each young man held his instrument, and hopefully the center man was the director or pianist, though he is not listed as such. Their names were recorded, from left to right, as Bain, Atwater, Simons, McClymonds, and Baker. This was taken before the popular saying of "cheese" was used in photography. (Courtesy of the Flagg Township Historical Museum.)

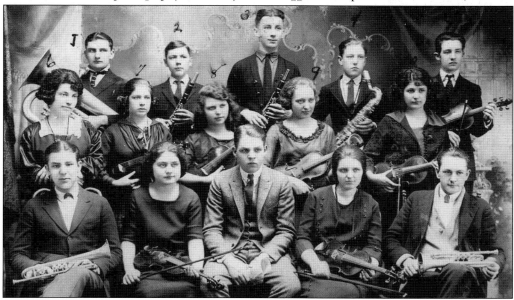

The 1922 Rochelle High School Orchestra was made up of, from left to right, (first row) Harold Valentine, Florence Shafer, Vince Carney, Grace Wedler, and Charles William Eyster; (second row) Miss Guggenheimer, Mildred Guio, Hanna Hayes, Agnes Anderson, and Gretchen Kittler; (third row) Clarence Shafer, W. J. Stopple, Lewis Pierce, Kenneth Valentine, and Clarence Brown. (Courtesy of FTHM.)

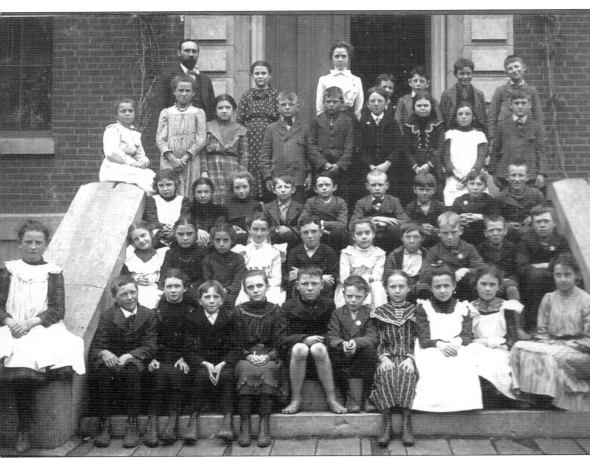

Professor Philbrook and Ms. Smith (center back) taught the fifth grade class in 1900. From left to right are, (first row) Ella Bowler (in white pinafore), William Lux, Loretta Marr, Carleton Healy, May Henshaw, Roy Govig, George Simons, Emma Beaderstead, Ada McConaughy, Eva Williams, and Francis Jaquay; (second row) Marge Unger, Clella Schrader, Imogene Schrader, Helen Southworth, John Dee, Ethel Cobb, Ralph Heath, Charles Ettinger, Jay Maxson, and Ben Berve; (third row) Editha McConaughy, Ollie Ray, Agnes Sammon, Paul Lazier, Art Tigan, Fred Larson, Gibson, Otto Weeks, and Charles Hanson; (fourth row) M. Woodrick (seated), Goldie Mayhew, Fern Baxter, Raymond Orput, Clarence Barnhart, Paul Rosenberg, Ada Orput, Alice O'Brien, and unidentified; (fifth row) Professor Philbrook, Gladys Rathbunn, Ms. Smith, Harry Perkins, George McMann, George Albertson, and Verill Clinite. (Courtesy of FTHM.)

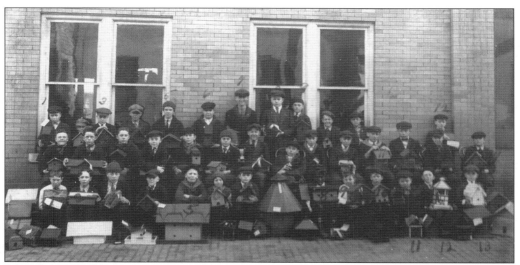

A birdhouse-building contest was held for the young Rochelle lads. The boys and their entries are shown on Dewey Avenue, in front of the Harter and Vaughn Bottling House. At the time of this photograph, the manual training classes for the grade schools were located in upstairs rooms on Dewey Avenue. (Courtesy of FTHM.)

Prom was and is always a highlight of the school year in Rochelle Township High School. Grace and Elmer Guio were prom chaperones on April 25, 1942. According to the *Tatler* yearbook, the "1942 seniors tripped the light fantastic at the prom." The junior class hosted the dance, earning money from a penny carnival, hot dog and mum sales, and a movie at the Hub Theatre. (Courtesy of John Guio.)

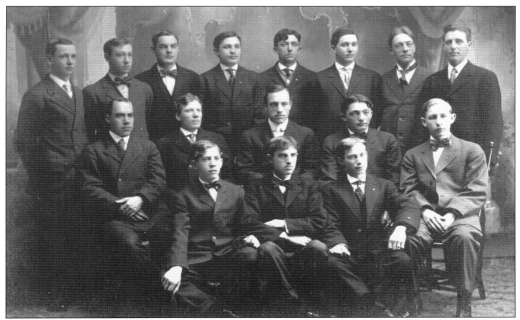

This is the Maple Leaf Club of Rochelle in 1909. Seen here are, from left to right, (first row) John Maxson, Bert Way, and J. M. Weeks; (second row) George Baker, Gus Maxson, Earl Baker, Herman Gable, and Stratford Coldlitz; (third row) Leon Ward, Mr. Ulen, John Adams, Alex Hodge, Cliff Halsey, Frank Malone, George Orchide, and Angus Holmblade. (Courtesy of FTHM.)

The old Rochelle Township High School contained an auditorium for the plays to be performed. Eventually the student actors used the gymnasium stage for their productions to accommodate larger audiences. In the 1930s photograph, all characters of the play line up in the spotlight for their bows. (Courtesy of John Guio.)

Eight

THE FUN OF ROCHELLE

From its inception, Rochelle has been an interesting city. Its dedicated citizens added dramatic buildings, such as the Bain Opera House, to offer theatrical groups, and later theaters brought the moving picture shows. The stage lines and the railroad offered the transportation.

Today life in Rochelle continues to offer a wide range of enjoyment.

Besides Spring Lake for swimming, the Rochelle Regatta is held yearly in June on Lake Sule. There are bike paths, a golf course, fishing, a skate park, Skare Park, Hickory Grove Fitness Center, fitness classes, and more.

Each year in May, the city offers Railroad Days that present basic festivities around the town as does the Lincoln Highway Heritage festival in August. This year's Heritage theme was "Agriculture . . . Then and Now." The activities included a car show, a truck and tractor show, stage entertainment, a fly-in, kids' zone, arts and crafts, a parade, and a small engine display.

An invigorating event for various stages of athletes awaits individuals in the Triathlon in June. The event covers beginners, advanced, and advanced-run and includes biking, running, and swimming. The proceeds from this event go to the Hub City Senior Center.

From June through September, Rochelle offers a farmers' market with fresh produce, flowers, herbs, and homemade jellies and jams. This is held behind the Flagg Township Historical Museum on Thursdays, and each year adds more vendors.

On April 23, 2006, Rochelle held its fourth annual Road Antique Show in the Holcomb State Bank building. Former WTTW (Chicago's Channel 11) appraiser Karen Holland was commentator and evaluated the intriguing items people brought for show and tell.

Since 2001, the refurbished Standard Oil Filling Station at 500 Lincoln Avenue has been the home of the Rochelle Visitor Center. The building boasts of the original 1918 station design with an original pump and equipment. The center is open year-round. Its Web site is as snazzy as the station at www.rochelletourism.com.

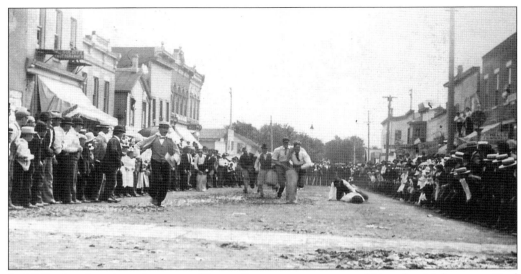

In 1905, the three-legged race on Cherry Street was an expected Fourth of July event. Fred Lux, editor of the old *Rochelle Independent*, acts as master of ceremonies. The large man of the winning duo is Olaf Lawson. The other men in the race are unidentified. The Lux brothers' print shop was located in the Turkington building at the right. (Courtesy of FTHM.)

In the gay 90s of the 1800s, bicycling was popular. The young women in this photograph stand in front Dr. Gould's home, which was located north and across the street from the Presbyterian Church. From left to right are Jessie Hall, Louisa May, and Anna Gould. (Courtesy of Flagg Township Historical Society.)

Bain Opera House was a mighty structure built by Angus Bain and was eventually converted into one of the finest office buildings. Old Mr. Smith had been its janitor. D. J. Hooley brought the first moving picture show to the theater with a high-class Chicago vaudeville. The Princess, the Majestic, and the Venetian theaters also held picture shows. (Courtesy of FTHM.)

The McGibney family of Janesville, Wisconsin, was a group of theatrical singers, who played at the Bain Opera House in 1888. They were typical of the many talented family troupes which traveled to perform shows during this period of history. Even the children performed. (Courtesy of FTHM.)

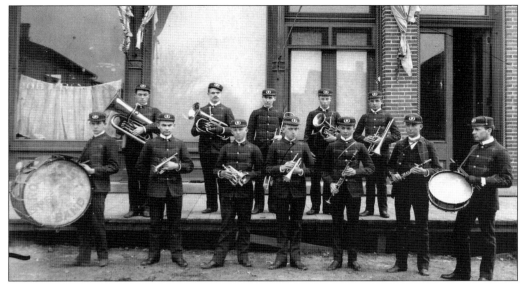

The Rochelle Boys Band was given nationwide acclaim by author Earl Chapin May, Rochelle native, in his *Saturday Evening Post* article. Seen here are, from left to right, (first row) Clam Eyster, Elmer Countryman, Arthur Lazier, Lloyd Ingraham (who later directed Hollywood movies), F. Palmer, Will G. Carey, and Willis Calkins; (second row) Edward Cleveland, Clint Hartong, George England, John Bain, and Wilbur McHenry. (Courtesy of FTHM.)

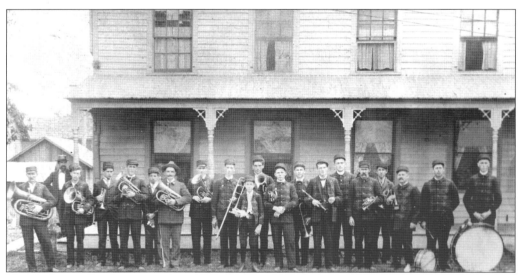

The Lafayette Band organized in 1875. In the 1898 photograph are, from left to right, John Drummond, McAdams (hotel owner), Ed Hardesty, Coan Wright, Perley Cross, Andy Tilton, Hart Orner, George Cleverstone, Andrew Tilton, Charles Drummond, John Boyle, Oscar Porter, Roe Millard, George Orner, Ernest Cooley, Joe McCanley, George Cann, Fred Roe (band leader), Art Dugdale, and Charles Cross. The band built the Lafayette Band Hall on Moats' farm. In 1920, it united with Rochelle Band. (Courtesy of FTHM.)

The Hub Theatre on South Main Street offers movies today. Begun in 1930 by funds from many of Rochelle's business people and other citizens, the Hub Theatre proved to be one of the most modern and beautiful theaters in northern Illinois. It boasted of seating 1,000 customers and a $25,000 organ. Plus the theater could operate the biggest stage show attractions. Air-conditioning was one of its modern comfort features. (Courtesy of FTHM.)

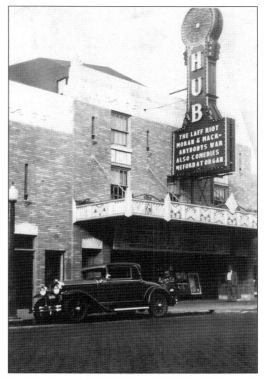

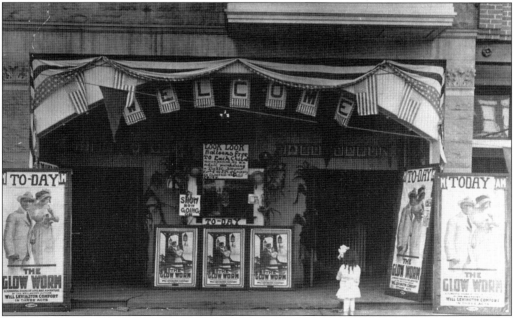

The Princess Theater was one of the first moving picture houses in Rochelle, located on the west side of Lincoln Highway. The theater was managed by Mr. and Mrs. Bob Weik. Mary Tilton, daughter of Floyd Tilton, is the little girl in front. Mrs. Weik sells tickets in the booth. (Courtesy of FTHM.)

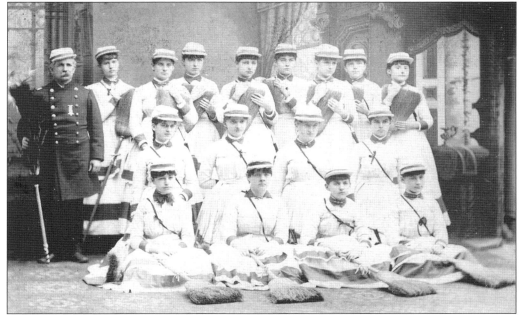

J. G. Gammon organized the Broom Club for young women. This photograph, taken in 1885, shows Gammon at the left, who also trained the 16 women for the drills. They were local entertainment for social gatherings in that era. The only woman identified is Louisa May, standing next to Gammon, who also led young men in drill organizations. (Courtesy of FTHM.)

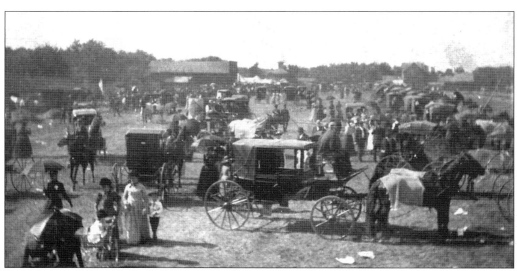

Fairs meant fun, cotton candy, warm weather, and exhibits. This photograph was taken from the Rochelle grandstand, looking north. The dining hall stands in the distance. A woman in the left foreground pushes her babe in a pram with big wheels. The time was September 1890, and hopefully the weather was not too hot to wear those clothes. The horses are wearing their fly nets. (Courtesy of Flagg Township Historical Society.)

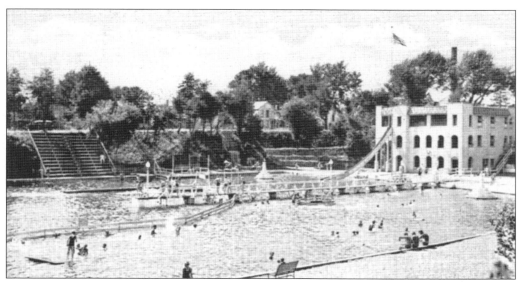

Spring Lake swimming area was built upon Braiden's stone quarry in the early 1900s. This postcard picture shows the two fountains: one in the center and its twin to the right. A long pier from the large bathhouse provided a diving board at the deep end. A high, long slide in front of the bathhouse enticed children of all ages to enjoy its thrill. (Courtesy of Flagg Township Historical Society.)

The Rochelle Tourism and Visitors Center at 500 Lincoln Avenue is a renovated, 1918 filling station. The small building contains loads of information about Rochelle and offers a walking tour with printed material and a CD for the car and brochures on the sights and opportunities in the city. A few of the festivities include Railroad Days in May, the Rochelle Triathlon in July, and a Christmas Walk in December. (Courtesy of Marie O'Connor.)

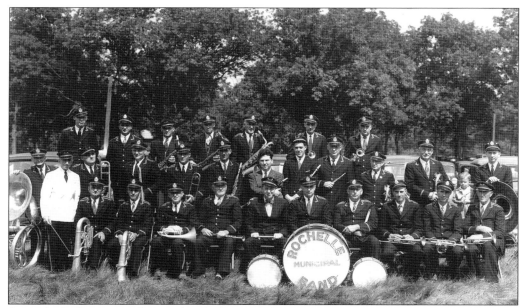

Once the Lafayette Band merged with the Rochelle Municipal Band, they played weekly during the summer at the city band shell. This band photograph from around the 1940s shows that many of the members were dedicated older gentlemen. Do they have a young mascot? Where have all the ladies gone? Are they in the audience? (Courtesy of FTHM.)

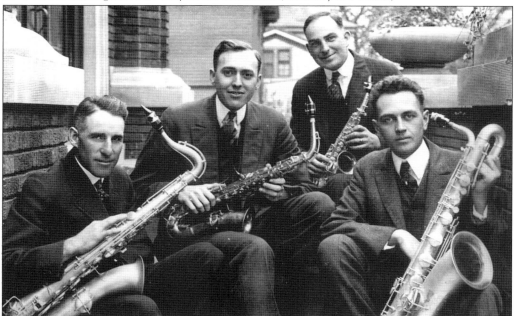

The saxophone quartet was popular during the days that the Illinois Club was active. The young men are, from left to right, Merritt Leonard, Joe Olson, Art Atwater, and Charles Kepner. The men pose on the Flagg Township Library steps when the building was new. The house in the background belonged to James Brundage and is now the location of Unger-Horner Funeral Home. (Courtesy of FTHM.)

BIBLIOGRAPHY

Barnes, Betty and Estelle Von Zellen. *Book of Rochelle*. Self-published, 1976.

City of Rochelle. Rochelle Centennial Program. Rochelle: 1953.

City of Rochelle. Rochelle Sesquicentennial Souvenir Program. Rochelle: Printing Etc., Inc., 2003.

Flagg Township Historical Museum. Rochelle: Forest Preserve District of Cook County, 1964. http://www.newton.dep.anl.gov/natbltn/700-799/nb748.htm.

Gingerich, Robert. Historic Rochelle Walking Tour booklet. Rochelle, 2006.

Kruger, Franklin. *Bits of Rochelle Area History*. Rockford: Adams Letter Services, Inc., 2004.

Kruger, Franklin. *History of Rochelle and Flagg Township, Illinois*. Rockford: Waldsmith Illustrators, 2000.

Kruger, Franklin. "An Indian Trail Tree near Rochelle, Illinois." 1969.

Nelson, Art. "Notes." 1940s, 1950s.

O'Brien, George D. and Chuck Stafford. Rochelle Diamond Jubilee program. 1928.

Ogle County American Revolution Bicentennial Commission. *Bicentennial History of Ogle County*. Ogle County: Ogle County Board, 1976.

Pemberton, John. "The Driscoll Gang." Oregon High School, 2001. http://www.lib.niu.edu/ipo/2001/ihy010236.html.

Rochelle Area Chamber of Commerce. 2006 Rochelle Area Community Guide. Rochelle, 2006.

Van Briesen, Armour. "The Black Hawk War and Stillman's Run, Ogle County, Illinois 14 May, 1832." http://www.comportone.com/cpo/genealogy/articles/localhistory/BlackHawkWar.htm.

Whitcomb Locomotive Company. http://en.wikipedia.org/wiki/Whitcomb_Locomotive_Works.

ACROSS AMERICA, PEOPLE ARE DISCOVERING SOMETHING WONDERFUL. *THEIR HERITAGE.*

Arcadia Publishing is the leading local history publisher in the United States. With more than 3,000 titles in print and hundreds of new titles released every year, Arcadia has extensive specialized experience chronicling the history of communities and celebrating America's hidden stories, bringing to life the people, places, and events from the past. To discover the history of other communities across the nation, please visit:

www.arcadiapublishing.com

Customized search tools allow you to find regional history books about the town where you grew up, the cities where your friends and family live, the town where your parents met, or even that retirement spot you've been dreaming about.